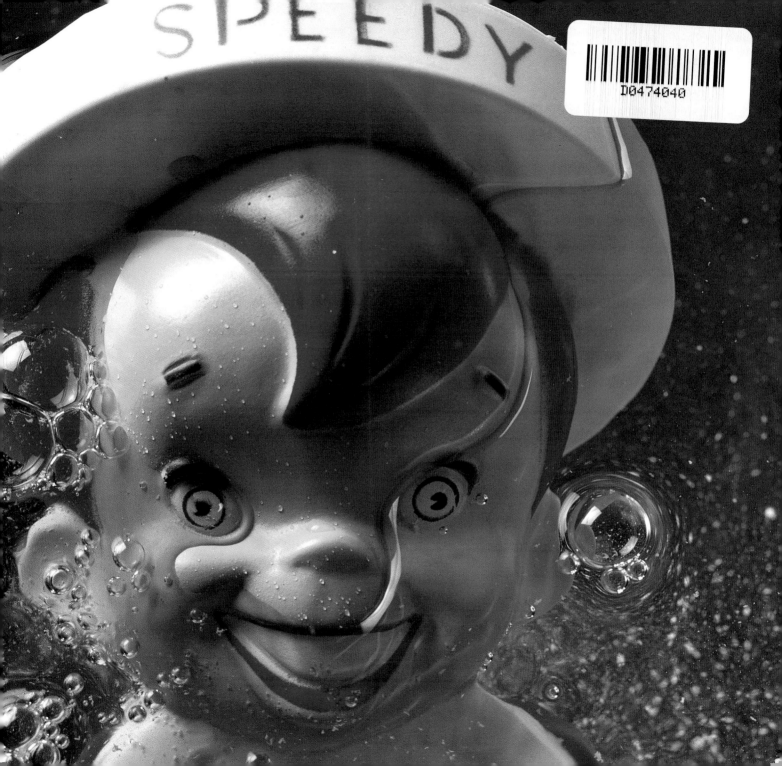

What a Character!

20th Century
American Advertising Icons

By Warren Dotz and Jim Morton Photography by John William Lund

CHRONICLE BOOKS SAN FRANCISCO

Very special thanks to James Maley, who provided some of the prized packaging and advertising artifacts that appear in this book, and to Michelle King for her invaluable assistance with the text.

The authors wish to acknowledge Bill LeBlond, Leslie Jonath, and Michael Carabetta at Chronicle Books for their direction and support. Thanks also to Jeff Errick, Ed Polish, Robyn Talman, and Ellen Weis of the Museum of Modern Mythology for their help and support over the years.

For sharing their knowledge of advertising collectibles, the authors would like to thank Jim Ed Garrett, Teddy Schapiro, Jim McClane, Chuck Evarkiou, Dan Goodsell, Jim Waite, Greg Favors, and Karen Robinson. For their valuable advice and enthusiastic support, the authors would like to thank Rick Seireeni, Andy Levison, Gerry Rouff, David Weingarten, Margaret Majua, Anna Marie Lund, and Bridget Schwartz. And special thanks to Maki Shultz.

Library of Congress Cataloging-in-Publication Data:
Dotz, Warren
 What a character! : twentieth-century American advertising icons
 by Warren Dotz and Jim Morton ; photographed by John William Lund.
 p. cm.
 Includes index.
 ISBN 0-8118-0936-6
 1. Advertising—United States—20th century.
 2. Commercial art—United States—History—20th century.
 3. Symbolism in advertising—United States—History—20th century.
 4. Television advertising—United States—History—20th century.
 5. Stereotype (Psychology) in advertising—United States—History—
20th century. I. Morton, Jim. II. Title.
HF5813.U6D68 1996
659.1'0973'0904—dc20 91-21552
 CIP

Printed in Hong Kong
Book design: World Studio.

Distributed in Canada by Raincoast Books
8680 Cambie Street
Vancouver, B.C. V6P 6M9

10 9 8 7 6 5 4 3

Chronicle Books
85 Second Street
San Francisco, CA 94105

Web Site: www.chronbooks.com

Contents

Introduction

Like most children of the fifties and sixties, I spent too many hours in front of the television. I don't remember much about the programs I watched, but I do remember the commercials. Even at the tender age of ten I recognized that if I wanted to learn anything about this world, I had to start with the things that everyone took for granted. By watching television commercials I learned many things. I learned of the gulf between what people wanted to be and how they actually saw themselves. I learned that, in the minds of advertisers, breakfast cereals, chewing gums, and candies were magical concoctions, capable of transporting us to imaginary realms. I learned that new cars and bad colognes held strange attractions for beautiful women.

As an adult, looking back on the advertising of my childhood, I found that the products I remembered best were the ones that used some sort of advertising character. Like countless other children across the country, I begged my mother to buy Nabisco Rice Honeys; not because I liked it (I actually didn't!), but because I liked Buffalo Bee and he said it was the best cereal. As a child it seemed that products with unique characters spoke to me individually. I didn't realize until I was much older that this was no accident.

Commercials are the language of the free market. Like any language it changes to fit the times. At the turn of the century, the language was simple. As commerce grew and changed throughout the century, advertising grew and changed with it. If, as Calvin Coolidge once claimed, the business of the American people is business, then this book is as much about America in the twentieth century as it is a chronicle of advertising characters.

This book is arranged in a modified historical form. Characters are examined based on when they first appeared and also according to which character type they best represent. The first three chapters cover the realistic human and animal characters, starting from before the turn of the century, as well as the more obvious literal characters, all of which

Buffalo Bee
Nabisco
Rice Honeys
1957

were common to early advertising. As the century progressed, advertising design—like all other art forms—was heavily influenced by the apocalyptic upheavals occurring in the European art community. The next three chapters examine this phenomenon, showing the correlations between seemingly unrelated art manifestos and the advertising world. The last two chapters cover the effects of television on advertising.

We discuss characters according to the category that they best illustrate as a style or a character type. In the chapter on human characters, for instance, we cover the Quaker Oats Man, Aunt Jemima, and other early characters, and then go on to discuss more recent human characters, such as Orville Redenbacher and Colonel Sanders. Some possess features described in more than one category, of course. Speedy Alka-Seltzer, for instance, could be considered a literal figure or a sprite or even a mischievous little boy, but we decided he was critical to the development of personalities on television, so that's where we put him.

The last chapter on the story of advertising characters has yet to be written. As the public gets more savvy, advertisers follow suit. A new approach to advertising is changing the playing field substantially: product tie-ins and children's television shows created with the marketing potential of the show's characters in mind are blurring the distinction between what is advertising and what is not. While these developments are beyond the scope of this book, they do demonstrate that advertising is a living thing, growing and mutating according to its needs and its environment. If you understand that, you understand the essence of advertising.

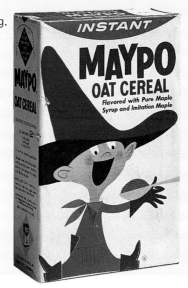

Marky Maypo
Maypo oat cereal 1958

Human Characters:
A New World Begins

Around 1860, the world ended. It was smashed to flinders by something called the Second Industrial Revolution. In the first half of the nineteenth century, the western world had shifted away from the farms and into the cities as the Industrial Revolution took hold. From 1860 until the early part of the twentieth century, the world saw even greater changes as we moved into a new, technology-based society. Prior to 1860, most goods were sold and packaged on a local basis only. Which product you bought was based on word of mouth from your neighbors ("Old man Kiley has a fine crop o' corn this season") or on your own judgment.

The closest thing to nationally marketed products were the patent medicines sold by traveling salesmen. Using a technique similar to that of modern infomercials, these pitchmen went from town to town demonstrating their products. Shills were planted in audiences to give the impression that the medicines were capable of miraculous cures. Too often the products proved useless or, worse, downright fatal—which didn't help the development of nationally recognized name brands.

With the Industrial Age came mass production and mass transportation. Mass production enabled manufacturers to produce their goods in quantities previously unimaginable. Mass transportation gave them the wherewithal to

Smith Brothers
Smith Brothers cough drops early 1960s

disperse these goods on a national and eventually global basis. People started recognizing products by their packages, and it didn't take manufacturers long to realize that mnemonic devices, such as logotypes or distinctive characters, might help single out their products in the minds of consumers.

The earliest advertising characters were human, with little or no exaggeration of form. Many of these were based on common perceptions (or misperceptions) about certain races, nationalities, or subcultures. They gave products an immediate sense of familiarity. In a sense, they gave products personalities.

An example of this type of character is the Quaker Oats Man. He is one of the oldest advertising characters that is still in use today. None of the manufacturers involved in what eventually came to be the Quaker Oats Company was a Quaker. The choice of product endorsement came from the popular opinion at the time that Quakers were moral, healthy, and clean people. The Quakers— more accurately known as the Society of Friends— weren't happy with the association. They went to court to have their name removed from the breakfast cereal but were unsuccessful. Ironically, the term "Quaker" was originally used as a slur by a judge, responding to the group's founder George Fox's remark that the judge should "tremble at the word of the Lord."

The Quaker Oats Man represents a stereotype, but it is a relatively benign stereotype. Compare him to Aunt Jemima, whose origins date back to the minstrel shows of the last century. The prevalent white images of the supplicating Mammy and Uncle Tom were used as sources of ridicule by minstrel performers, both black and white.

Although slavery had been abolished forty years before the century began, the position of black people had barely improved. Most of the work available to them was as servants. Black women found work in the homes of the rich, where they were hired as maids, cooks, and nannies (usually referred to as "mammies"). The black woman's reputation for good cooking grew, until the stereotype developed: the fat, black woman with her hair wrapped in a red bandana, cooking all day to bring you the best food you ever tasted. The title "aunt" was a throwback to the days of slavery. "Mr." and

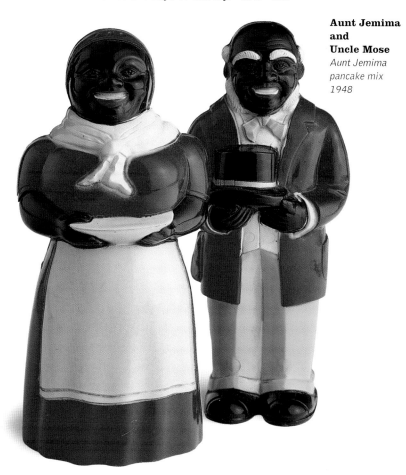

Aunt Jemima and Uncle Mose
Aunt Jemima pancake mix 1948

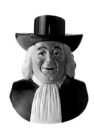

Quaker Oats Man
Quaker Oats cereal late 1950s

Kleek-O
Cliquot Club ginger ale 1930s

"Mrs." were not used when referring to slaves. Up to the age of fifty, black men were called "boys"; after that, they were called "uncles." Likewise, women went from "girls" to "aunts." In this way white Americans avoided giving black Americans the same respect they demanded of each other.

When Chris L. Rutt and Charles Underwood developed the first pancake batter mix, they borrowed Aunt Jemima's name and appearance from "Old Aunt Jemima," a popular minstrel song and dance routine of the time. In 1883, Rutt and Underwood wanted a real woman to portray Aunt Jemima at the World's Colombian Exposition in Chicago. After scouting around, they chose a local Chicago woman named Nancy Green, who worked for a prominent judge. She had the look that Rutt and Underwood were after, and it turned out she was a good cook to boot. Her appearance at the exposition was a huge hit and was the first time a real person was used to portray an advertising character. In 1925, The Quaker Oats Company bought the Aunt Jemima Mills. By that time Aunt Jemima was known to virtually everyone in America.

Since her creation Aunt Jemima has changed dramatically. She no longer wears a bandana on her head. She has also lost quite a few pounds in recent years. Today she is as innocuous as her white counterpart, Betty Crocker.

There would probably have been more examples of mammies as advertising characters if Aunt Jemima Mills had not protected its character so vigorously. Any entrepreneurs trying to use characters too similar to Aunt Jemima quickly found themselves in court. Nonetheless, Aunt Jemima was not the only mammy out there. Similar in appearance, although slightly thinner, was Luzianne

Mammy, created for Wm. B. Reily and Company to sell its Luzianne brand coffee.

We all know Aunt Jemima, but did you know that she had a male counterpart named Uncle Mose? Like Aunt Jemima, Uncle Mose got his name from a popular song, titled "Old Man Mose." Mose was rarely used to sell products. It seems his main reason for being was to allow the Quaker Oats Company to create Aunt Jemima salt and pepper shakers, which it sold as an advertising premium.

Uncle Mose wasn't the only black man used to sell products. When the Cream of Wheat Company wanted a character to represent its product it chose a smiling black waiter, holding a steaming bowl of the cereal. The character was given the name

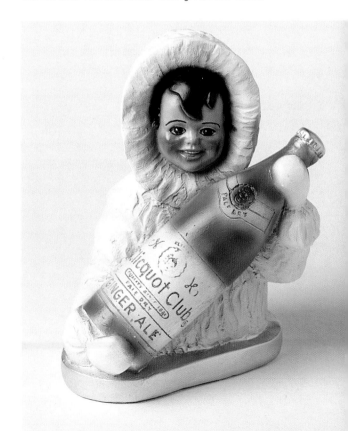

Rastus, a name now associated with the worst racial stereotypes. The appearance of Rastus was taken from an actual waiter, whose smile charmed the manufacturer. Although the image of Rastus went on to become one of the most recognized images in the world, the original waiter never received either money or recognition for his part in the birth of the trademark.

Black children were also popular with advertisers. Two of the most famous were the Gold Dust Twins, who appeared on Gold Dust scouring powder packages. The Gold Dust twins were drawn by E. W. Kemble, a popular artist who specialized in racist caricatures of blacks, which he referred to as "Coons." Kemble's illustrations appeared in several newspapers, magazines, and books. During the thirties the Gold Dust Twins were as well known as Tony the Tiger is today.

Native Americans were used to sell everything from butter to cars to life insurance. Like the Quaker Oats Man, they were used to represent healthy and natural products. We are all familiar with the Land o' Lakes Indian Maiden, who suggests to us that the butter she advertises is as pure and healthy as she is. Eskimos were a natural choice for anything cold; hence the creation of Kleek-O the Eskimo, used to sell Cliquot Club ginger ale.

Most Native American characters were used by companies or products that were named after individuals or specific tribes. Pontiac automobiles—named after the Ottawa Indian chief who attacked the Detroit settlement in 1763—had a stylized head of an Indian as their hood ornament. Pontiac also used a more cartoonish character for some of its advertising. Mutual of Omaha, playing off of the fact that the city was named after an Indian tribe, still

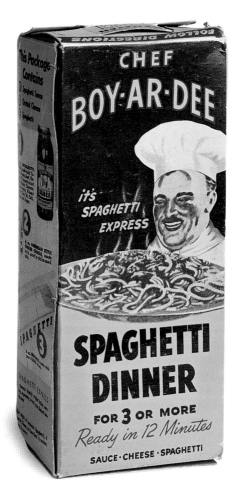

Chef Boy-Ar-Dee
Chef Boy-Ar-Dee spaghetti dinner late 1950s

uses a strong profile of an Indian in a full, feathered headdress as its logo. The Mohawk Carpet Mills took a more playful approach with Tommy Mohawk, a smiling Mohican boy holding a tomahawk.

Of the white minorities, Italians are, far and away, the most common characters. They are typically portrayed as mustachioed Italian cooks. In the case of Chef Boy-Ar-Dee, the character is based on an actual person. Hector Boiardi moved to New York from Piacenza, Italy, in 1914. A few years

Campbell Kid
Campbell's soups
mid-1950s

was noted for its cheaply made goods and America was seen as the place to get quality products. Sony Boy may have been a way of saying that "our goods are as well made as American goods," using a decidedly American-looking child as the mascot. Nowadays Sony no longer needs to prove that it makes good products, and Sony Boy is rarely seen. Perhaps in the near future some American company will use a Japanese kid as its advertising character for the same reasons that Sony chose the Sony Boy!

Muscular and fat people are natural candidates for advertising characters. Strongmen are used to represent products that require strength or durability. Overweight characters are used to sell food products. After all, who do we trust to deliver the best tasting food: a fat or a skinny chef? Obviously we choose the one who apparently loves food the most.

Westinghouse Electric Corporation used a character called "Tuff Guy" to personify the strength and durability of its home appliance line. In his early incarnation, the Westinghouse Tuff Guy was a gruesome-looking, bare-chested troglodyte with a surly frown. Later on, the Tuff Guy lightened up, smiling and wearing a T-shirt, apron, and chef's cap. About the only thing he has in common with his earlier version is his physique.

Among fat character types none is more popular than the Campbell Kids. The Campbell Soup Company was making a name for itself with its line of condensed soups when a young illustrator named Grace Wiedersham Drayton showed her drawings to its executives. Grace had a talent for drawing chubby, cherubic children. The executives were delighted and felt that Grace's drawings would be perfect for advertising Campbell's soups. Although they have

later he moved to Cleveland, Ohio, where he became the head chef at the Hotel Winton. When customers started requesting his spaghetti sauce, Hector saw the potential and moved into the packaged foods business. He phoneticized the spelling of his name because Americans had trouble pronouncing it correctly.

When we think of racial advertising characters we think only of American minority groups, but what about Sony Boy? He was the Sony Corporation's early mascot. No longer in use, Sony Boy was a cheery little white kid with big ears and brown hair. Akio Morita, the president of Sony, said that the initial goal of his company was to reverse the common perception that things made in Japan were cheap throwaway items. During the fifties, Japan

lost some weight in our recent weight-conscious times, the Campbell Kids are still in use today.

A less conspicuous hefty character is the Sunshine Baker. Most people are only familiar with him in passing. We seldom stop to notice the little fellow on every package of cookies or crackers that Sunshine Biscuits makes. Though nearly subliminal, he well represents the stereotype of the fat and happy baker.

A favorite chubby character is Big Boy, who was named after the double-deck cheeseburger Bob Wian sold at his small restaurant in Glendale, California. Wian's fat kid and the Big Boy sandwich were such hits that soon Wian had restaurant chains all over California. In 1984, the Marriot Company, who bought the franchise in 1967, held a vote to determine whether Big Boy should retire. Big Boy won by a huge margin and is still in use today.

Big Boy also represents another type of character: the mischievous boy. Boys between the ages of six and twelve are used as ad characters to sell everything from potato chips (Chesty Boy) to scouring pads (Chore Boy). Often slightly

mischievous, these characters are always healthy looking. They appeal to men and boys because they see themselves in the characters.

Marky Maypo represents an even more stylized mischievous boy. In Marky's case, the main crime was his refusal to eat his Maypo cereal. When his Uncle Ralph tried to help convince the boy to eat by downing a few spoonfuls, Marky panicked. "I want my Maypo!" the boy screamed, and soon the words were on everyone's lips, the perfect expression of a child's temper tantrum.

A well-known mischievous boy that is easily overlooked as an ad character is Bazooka Joe. Anyone who has ever chewed bubble gum is familiar with his adventures, which appear on colorful wax-paper cartoon strips inside every piece of Bazooka bubble gum. Joe, along with his girlfriend Zena and his weird pal Mortimer (he's the one with the turtle-neck covering his face), first appeared in 1953 and were immediately a hit with kids. They have changed a little over the years—the fortunes are now often jokes, and a current series of Bazooka Joe strips is titled "Bazooka Joe Raps." The Bazooka Joe comics are printed in eight languages. Some of the strips are reworded for different parts of the world. The strips that appear in Spain, for instance, are slightly different from the ones that appear in Mexico.

Babies were also used as early ad characters. The most famous, the Gerber Baby, started as a rough sketch and stayed that way. When artist Dorothy Hope submitted her charcoal sketch of a baby, it was intended for preliminary approval before actually completing a planned oil painting. Company executives liked the sketch so much they decided to use it as their trademark.

A less pleasant but more humorous child is the

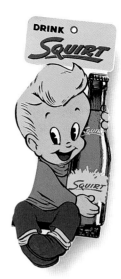

Little Squirt
Squirt
1949

Jell-O Baby
Jell-O brand gelatin dessert
1952

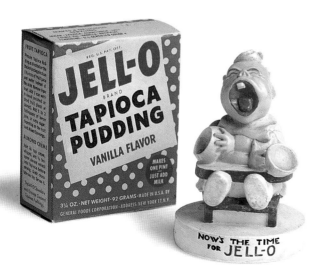

Jell-O Baby who appeared in ads in the forties and fifties. The baby was shown holding two empty bowls, crying for more. The slogan read "Now's the time for Jell-O," implying that serving Jell-O might be a way to keep your kids quiet.

For services, or products related to services, tradespeople were often used. Harry Hood, the milkman for the H. P. Hood dairy company, the Oertels bartender, and Miss Curity, the Curity bandage company's nurse, are just a few examples. A more imaginative use of an occupational character is the Little Man with a Hammer used by the Western Extermination Agency. Instead of dressing him in the garb of an exterminator, he is dressed like an undertaker. The inference is obvious, but to further state the case, the little man is shown holding a large hammer behind his back while trying to coax a nearby rodent to come closer.

Some character and product associations are harder to figure out. The Dutch Boy, used by the Dutch Boy Paint Company, was chosen partially because of the belief that Dutch people kept their houses painted spotlessly white. He was chosen also because the manufacturer used a so-called "Dutch" process to make its white lead paints. As a character the Dutch Boy is relatively unremarkable, but he has stood the test of time.

The Fisk Tire Boy started with a bad pun. The original ads showed a sleepy child holding a candle with a tire slung over his shoulder. "Time to re-tire," the caption read. Another example of a pun-based human character was Gen'l Mills, who was used

briefly to promote—what else?—General Mills. Little Squirt, the short blond kid used to sell Squirt soft drink, is yet another example.

At the turn of the century, advertising characters were given less forethought than they are today. If a character made sense thematically, it was used. This is not to say that advertising characters were created haphazardly. The Morton Salt Girl, for instance, was chosen from a selection of drawings based on the expected popular appeal of the character. The accompanying slogan, "When it rains, it pours," was a rewording of the old adage "it never rains but it pours" with the negative connotation removed. The techniques for slogan and character design that the Morton Salt Company developed are still used by ad agencies today.

Many human characters represent stereotypes. How offensive we consider these stereotypes depends on the times. Take for example the image of the housewife. For any household cleaning product, the housewife was a natural choice. That is why the S.O.S. Company used Mrs. S.O.S., an average-looking housewife, as its character. Prior to the renewal of the feminist movement people gave little thought to this stereotype.

The queen of all housewives was, and still is, Betty Crocker. Named after William Crocker, a board member at the Washburn-Crosby Company, Betty Crocker was designed to represent the average American housewife. When the Washburn-Crosby Company joined forces with several other milling companies to form General Mills, Betty became a national figure. Her position as queen of the

American kitchen remained unchallenged until 1972 when the National Organization for Women filed a class action suit against General Mills, claiming that Betty Crocker promoted sexual and racial discrimination by promoting the image of the woman as homemaker.

Stereotypes, no matter how offensive, are drawn from real people. In the case of Harland Sanders, inventor of Kentucky Fried Chicken, he actually became the stereotypical Kentucky Colonel, a relic of the post–Civil War South. Sanders created the persona out of whole cloth. He wasn't a colonel of any sort (although the state later made him an honorary Kentucky colonel), but he did know how to cook chicken. With his white suit, goatee, and string tie he effectively recreated himself in the image of an advertising character. The results were hugely successful. Today he is one of the most recognized characters in the entire world. Unfortunately for him, his skill at personifying his product was too good. When Heublein Incorporated bought the Kentucky Fried Chicken Company in 1971, the quality of the product plummeted, reportedly due to Heublein's lack of understanding about how the KFC

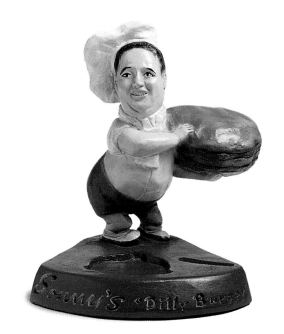

Sonny
Sonny's Drive-In, "Home of the Dillyburger" late 1950s

franchises worked. In 1976, Colonel Sanders was quoted as saying that the chicken at a New York City Kentucky Fried Chicken outlet was the worst he'd ever tasted. This got him in some trouble with Heublein, which was paying him $250,000 a year to promote KFC chicken. In 1977 the company started to turn things around, but eventually, in 1986, it sold KFC to Pepsico.

In the case of Wendy's, the smiling little girl was named after the daughter of the fast-food purveyor, Dave Thomas. But the character has more in common with Pippi Longstocking than she does with Thomas's actual daughter. As a historical footnote, Dave Thomas is the man credited with convincing Harland Sanders to open a chicken-only restaurant.

Ego may drive people to allow their faces to become part of their company's image, but ego alone is not enough. Care must be taken in the design of the character or the end result will be forgettable at best and downright grotesque at worst. Take, for

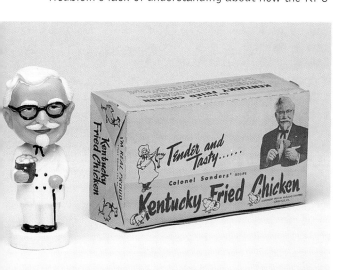

Colonel Sanders
Kentucky Fried Chicken mid-1960s and 1954

example, the ad character used by Sonny's Drive-Ins to sell their hamburgers. The face of Sonny was attached to the body of a very small child who holds in his hands a gigantic hamburger. The resulting character verges on the perverse.

A personality type that is rarely used today is the "dapper Dan"—the impeccably groomed young man-about-town from the roaring twenties. The Meltonian shoe cream man is an example of this. Young and well groomed, the Meltonian Man was a perfect representative for a company that specialized in expensive shoe polishes. Dapper Dans were used to advertise products associated with good taste and high style. Johnnie Walker, with his

English hunting outfit, also falls into this category. The character implies that the sophisticated drinker drinks Johnnie Walker.

A more cartoonish and foppish variation on the dapper Dan is Esky, the bug-eyed fellow with the enormous blond moustache who represents *Esquire* magazine. Esky is not as self-assured as the Meltonian Man or Johnnie Walker. He always looks slightly befuddled. The one thing we know about him is that, like all dapper characters, we can trust his taste. In this case, trusting his taste means reading *Esquire* magazine.

Today, human characters based on stereotypes are rarely used. We as a society have gotten too touchy to allow such things. A trend that started with Colonel Sanders and has become more prevalent over the past ten years is the use of company owners to advertise their products, becoming, in effect, their own advertising characters. This works best with charismatic or eccentric-looking individuals such as Wendy's Dave Thomas or Orville Redenbacher. When a company has no eccentric or interesting people in its upper echelons, it can fabricate them using actors, as is the case with the folksy duo Bartles and James.

Tropic-Ana and Velveeta
Tropicana orange juice and Kraft Velveeta mid-1960s

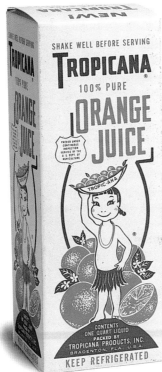
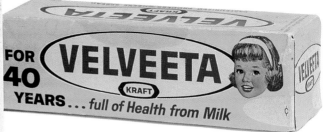

Dutch Boy
Dutch Boy paints
1936

**Tommy
Mohawk**
Mohawk carpets
1957

**Luzianne
Mammy**
*Luzianne coffee
and chicory
mid-1950s*

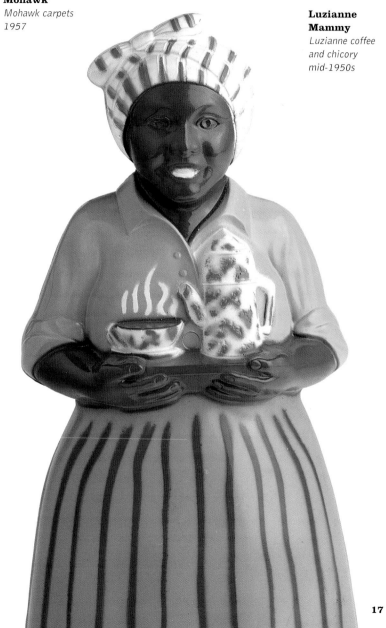

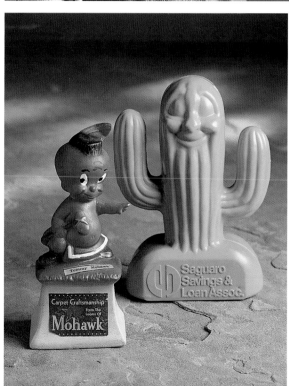

Chesty Boy
Chesty potato chips
1962

Big Boy
Big Boy restaurants
1970s

Sony Boy
*Sony hi-fidelity
products
mid-1960s*

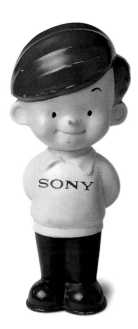

Big Boy
*Big Boy
restaurants
1993*

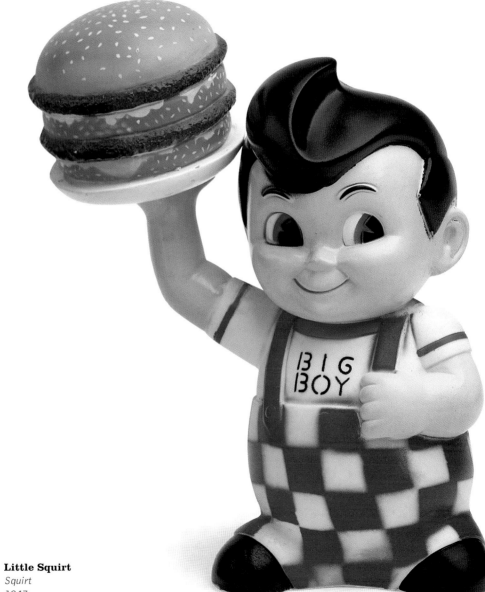

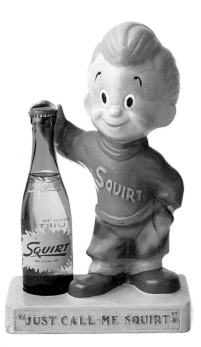

Little Squirt
*Squirt
1947*

**Westinghouse
Tuff Guys**
*Westinghouse
appliances
1952 and 1940*

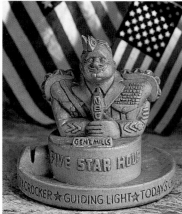

Gen'l Mills
*General Mills
sponsored NBC
radio network
shows
1938*

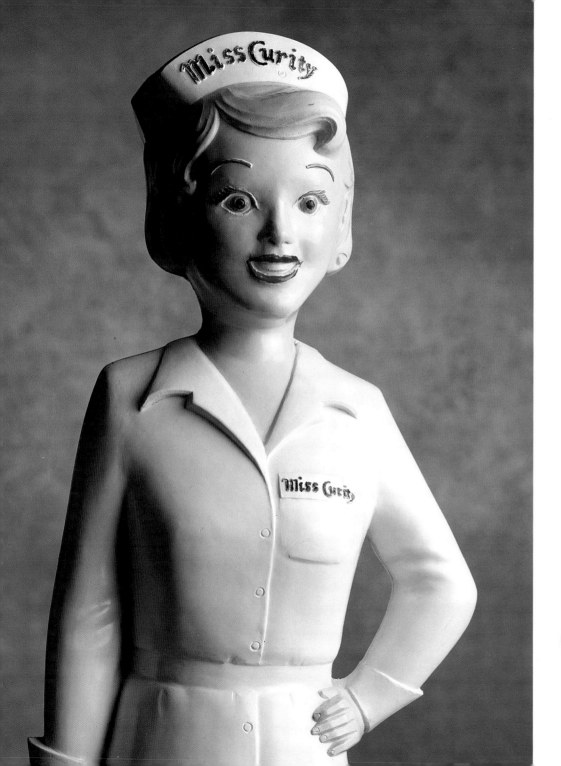

Miss Curity
*Curity brand
medical bandages
mid-1950s*

Mrs. S.O.S.
*S.O.S. magic
scouring pads
1959*

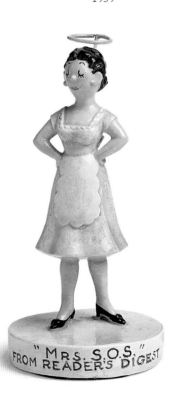

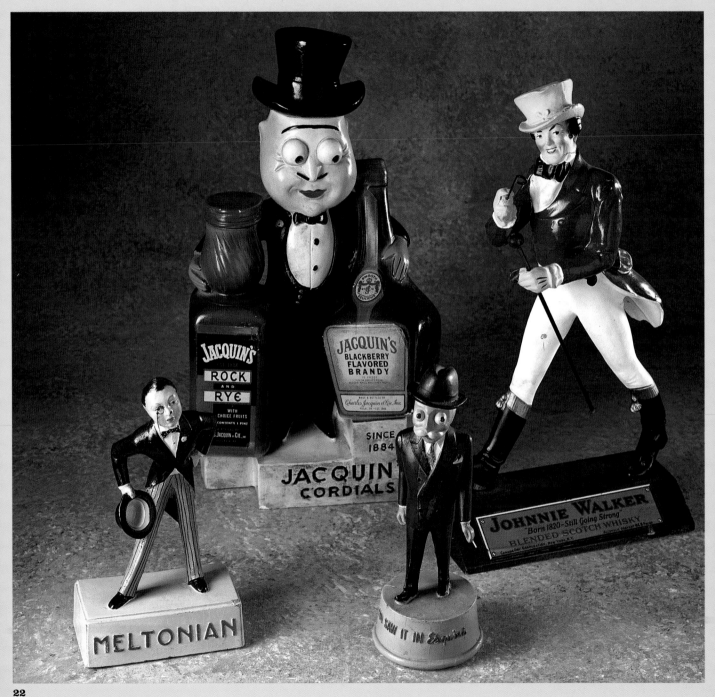

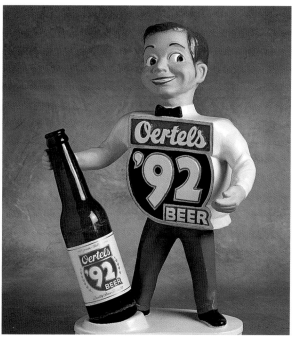

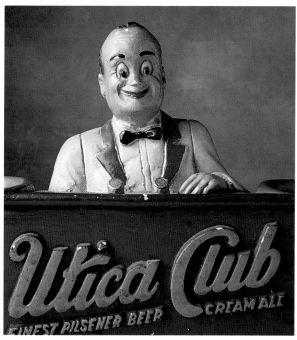

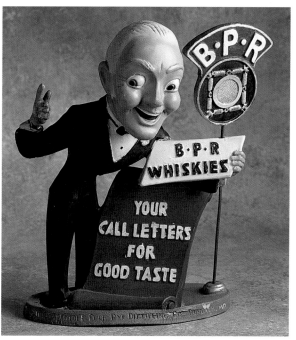

Dapper Dans:
Meltonian
Man
Meltonian shoe
polish
1930s
Gaston
Jacquin's cordials
early 1950s
Esky
Esquire *magazine*
late 1940s
Johnnie
Walker
Johnnie Walker
scotch whiskey
1980s

Esky
Esquire *magazine*
1940s

Oertels
Bartender
Oertels '92 beer
1954

Utica Club
Bartender
Utica Club beer
1948

B.P.R.
Announcer
B.P.R. whiskey
1939

Literal Figures:
A Century Turns

Manufacturers quickly realized that advertising characters help sell products. Human characters were the most common at the turn of the century; literal figures came along soon thereafter. Literal figures took a bit more imagination to create than their human counterparts, but not much. The idea is simple: turn your product into a character. Add a face or arms and legs and presto—you've got an advertising character. If you sell belts, make your character a belt with a face on its buckle, like Royal London's Belt Man. If you sell beer, then give your character a beer can or bottle as its body; or you can do as Blatz Brewery did and create a whole assortment of characters made out of cans, kegs, and bottles.

Blatz Man
Blatz beer
1959

If your product is not easily caricatured, you can get creative. You could caricature oil, for instance, by putting a face on a single drop of oil. That's what the Standard Oil Company company did, creating the Esso Oildrop. (Esso was one of the Standard Oil regional brand names, along with Sohio, Enco, Humble, and others. The name came from "S.O.," the company's initials. In 1973, the company changed its name and consolidated all of its brands under

the Exxon banner.) If you sell a service rather than a product, you can still use a literal figure by putting a face on one of your tools of the trade. That's the idea behind Otto the Orkin Man, the Orkin Exterminating Company's smiling, poison spray-can.

The oldest literal figure still in use today is Bibendum, better known to most people as the Michelin Man. When André Michelin was hired to take over a foundering rubber company, he immediately enlisted the aid of his imaginative brother Edouard. In 1891 Edouard created a new bicycle tire that used a removable air-filled inner-tube. Prior to this, bicycle tires were either solid rubber (which gave a bumpy ride) or had an air-filled tube glued to the rim. The removable inner-tube made it much easier to fix flat tires, and soon every bike owner in France was using Michelin's "pneumatic" tires.

The idea for Bibendum came to Edouard at an exhibition where he noticed a stack of tires that resembled a human torso. Four years later Michelin hired a poster artist to realize this idea. The character's name comes from the Latin *nunc est bibendum*, meaning "Let us drink," based on the company's slogan that Michelin tires "swallow up all obstacles." Bibendum was shown proposing a toast, holding a glass filled with nails, broken glass, and other road hazards.

Originally, the Michelin Man was a lusty, cigar-smoking fellow, who drank and partied in the best French tradition of *joie de vivre*. Although Bibendum has given up smoking and drinking, he maintains his vigorous spirit. In a recent advertising toy, Bibendum appeared riding a high-performance motorcycle.

The best literal figures are often simplest. The expression "a child could have done it" takes on a new meaning when you look at the history of one of the oldest and most enduring characters, Mr. Peanut.

When nineteen-year-old Amadeo Obici started his fruit stand in Wilkes-Barre, Pennsylvania, his decision to also sell roasted peanuts turned out to be a stroke of genius. The peanuts were a hit and within a few years Amadeo abandoned selling fruit altogether, opening the Planters Peanut and Chocolate Company. In 1916 the company offered a prize for the best trademark character idea. The winning drawing was submitted by a fourteen-year-old boy. An illustrator was hired to perfect the character, and the result is the Mr. Peanut we know today.

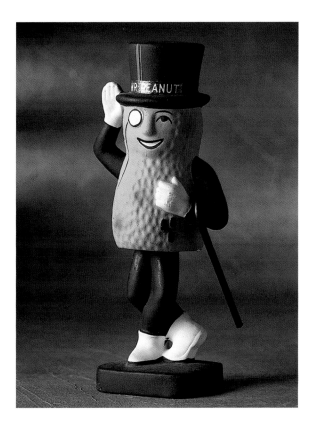

Mr. Peanut
Planters Peanuts
mid-1960s

Mr. Pear and Mr. Grape
fruit crate labels
1940s

Planters was one of the first companies to realize the sales potential of its advertising character. At a time when most other companies rarely offered ad-character collectibles as premiums for buying their products, Planters turned Mr. Peanut into a mini-industry. With a few empty wrappers and some change, you could send away for a wide assortment of Mr. Peanut premiums, including cloth dolls, banks, ballpoint pens, salt and pepper shakers, and other items. Many of these items are still available today, and Mr. Peanut shows no signs of disappearing.

Fruits and vegetables are natural candidates for literal figures. It's fun to attach human characteristics to fruits and vegetables. This is the appeal that Mr. Potato Head holds for millions of kids. It's no surprise then that many of the best literal figures fall into this category.

When the H. J. Heinz Company wanted to publicize its tomato juice it introduced Aristocrat Tomato. Like Mr. Peanut before him, Aristocrat Tomato was a cross between the dapper Dan human character and the literal figure. It's hard to gauge the impact and popularity of Aristocrat Tomato. He was well known, certainly, but he never became a superstar like Bibendum or Mr. Peanut. Not that the H. J. Heinz Company needed such a character. Its keystone logo and its

Salad Man
Kraft salad dressing
late 1970s

"57 Varieties" slogan were well known. In truth, from its earliest days the Heinz Company has always offered more than fifty-seven products. The number fifty-seven was chosen because founder H. J. Heinz liked it. Heinz was an oddity in the cutthroat world of business. A scrupulously honest man, he never left a debt unpaid and prided himself on the working conditions in his factory. After a vacation in Florida, Heinz returned to the factory with a fifteen-foot alligator that he installed in a glass cage above the main floor for the enjoyment of the workers.

A more extreme example of a vegetable-based literal figure is Salad Man, created to advertise the Kraft Company's salad dressings. Like Aristocrat Tomato, Salad Man has the head of a tomato, but that's where the resemblance ends. Salad Man is made entirely of vegetables. His torso is a head of cabbage; his arms are made of shallots. In place of legs he has an inverted stalk of celery. He looks like a pop version of a painting by Arcimboldo, the sixteenth-century court painter who painted still lifes of vegetables arranged to resemble human faces.

Not every advertising character is associated with a specific company. The Florida Orange Bird was created as an advertising tool for the Florida Department of Citrus to help the state's citrus growers sell their produce. The cheery little character appeared in TV commercials with Anita Bryant, fluttering around her head while she sang about the joys of Florida orange juice. As part of a massive advertising campaign in the seventies, the Florida Orange Bird's mission was to make oranges

synonymous with the state. The campaign was successful.

In the fruit and vegetable world there were dozens of lesser-known figures that graced the side panels of produce crates. Like mainstream ad characters, they were intended to give the purchasers (in this case, grocery store owners and produce buyers) memorable features by which to identify the produce.

Literal characters, like people, are products of their times. The dapper appearance of Mr. Peanut reflects a style of dressing that was popular at the turn of the century. Dressed in the colorful costume of a Carnaval samba dancer, Chiquita Banana took her cue from Carmen Miranda, a popular Brazilian singer-dancer who appeared in several Hollywood musicals in the forties. Carmen is best remembered for the outrageous production number "The Girl in the Tutti Frutti Hat," in Busby Berkeley's film *The Gang's All Here.* Originally Chiquita Banana was created to inform people about the proper methods to eat and store bananas. "Never," she reminds us, "put bananas in the refrigerator": an admonition that goes largely unheeded.

Chiquita Banana was a huge hit, but there was another problem still facing United Fruit Company. In the

store, one banana looks pretty much like the next. The company needed a way to distinguish its bananas from all others. It solved the problem by attaching a tiny sticker to every piece of fruit it sold. Today this is a common practice among fruit sellers, but at the time it was considered a radical and, to some, outrageous solution.

Behind Chiquita Banana is a company with a sinister past. The United Fruit Company was not averse to helping overthrow the governments in Latin American countries whenever the existing governments threatened to increase or impose import duties on its bananas. In 1954, after Guatemalan leader Jacobo Arbenz Guzman threatened to nationalize United Fruit's banana plantations, the company helped the CIA sponsor a revolution. From its practice of foreign intervention we get the expression "banana republic." In 1969, United Fruits became United Brands. After an ugly affair with the suicide of the company president and a scandal involving bribe money paid to the Honduran president, United Brands changed its approach. It has worked hard over the last twenty years to turn its image around by demonstrating more cooperation with the governments of the Central American countries from which it imports its produce. In 1990, United Brands became the Chiquita Fruit Company, enlisting the perky character to help improve its image.

Food-based literal figures are not confined to produce. There are plenty of examples of prepared products. Many drive-in restaurants have used images of happy-faced hamburgers as their logos, but none has been better known than Speedee, the

hamburger-headed character who adorned the McDonald restaurant signs in the fifties. Hot dogs have also been used as literal characters; Franky Man, used by Nathan's Famous Hot Dogs, is an example. Frozen custard characters include Mister Softee and Little Foster for Fosters Freeze.

In 1965, the Funny Face characters were created by the Campbell-Mithun advertising agency to advertise Pillsbury's new line of fruit-flavored drink mixes. The original lineup included Goofy Grape, Injun Orange, Chinese Cherry, Freckle Face Strawberry, and Rootin' Tootin' Raspberry. When people complained that Injun Orange and Chinese Cherry were racist, the two were quickly replaced by Jolly Olly Orange and Choo Choo Cherry. Other flavors included "With-It" Watermelon, Loud Mouth Punch, Lefty Lemonade, and Ruddi Tutti-Frutti. Each flavor had its own unique character. The leader of the gang was Goofy Grape, an insane-looking character in a Napoleonic cap.

Speedee and McDonaldland Hamburger
McDonalds late 1950s and 1960s

Unlike its rival Kool-Aid, which required added sugar, Funny Face was sweetened using a new artificial sweetener called calcium cyclamate. Calcium cyclamate tasted almost like real sugar and proved so popular that soon a host of new products was introduced using the artificial sweetener. Unfortunately, it also proved to be fatal—to lab rats, that is. When cyclamates were shown to cause cancer in laboratory animals, the FDA banned their use in all food products. Pillsbury reformulated its drink mixes using saccharin instead, but the sales started flagging. In 1980 the company sold the rights to Funny Face to Brady Enterprises, which currently manufactures the product on the Eastern Seaboard only.

Meanwhile Kool-Aid's smiling pitcher kept going strong. The fact that you had to add sugar to it didn't seem to bother people. Ironically, in the early television commercials the Kool-Aid Pitcher started out as an adjunct character to a pair of cartoon twins. The twins ran into all sort of adventures around the world, while the Kool-Aid Pitcher sat in the fridge singing, "Kool-Aid, Kool-Aid—tastes great! Ice-cold Kool-Aid—can't wait!" Eventually, the pitcher was put on the Kool-Aid packets and only after that did he become the star of the TV commercials. Like some other literal figures, the Kool-Aid Pitcher has become a marketing tool on his own. A wide assortment of Kool-Aid toys is now available.

Literal figures appeal strongly to children, so it's not surprising that advertisers often use them to sell products to the

younger set. When the M&M Company wanted to advertise its M&M plain and peanut candies it created the smiling M&Ms. The M&M Company was started by Forrest Mars, the estranged son of Frank Mars, founder of the Mars candy company, which is still one of the largest family-owned businesses in the world. The rift between father and son was so vitriolic that Forrest moved to England to sell candy there, never speaking to his father again. While in England, Forrest encountered a popular sugar-coated chocolate candy called "Smarties." After buying the rights, Forrest Mars joined forces with business partner Bruce Murrie to sell Smarties in the United States under the name M&Ms. At that time, M&M stood for Mars & Murrie. In 1964 Forrest merged his company with his late father's company, prompting more family feuds. Today, M&M stands for Mars & Mars. The M&M characters have been around since the fifties but have lately achieved superstar status, thanks to the marketing of M&M dolls and candy dispensers.

Mars advertised heavily on television throughout the fifties and sixties. Its biggest rival, the Hershey Food Corporation, did not. Hershey, at that time, had a policy against paying for advertising. "Give them quality," said the company founder, Milton S. Hershey. "That's the best kind of advertising." Obviously Milton never experienced the raw, psyche-shaping power of television. With the help of the M&Ms characters, during the late sixties Mars overtook Hershey as the leading candy producer in America. In 1970 Hershey abandoned its antiadvertising stance with a series of charming commercials, but it has yet to create characters as appealing as the M&M candies.

Some characters are slightly more abstruse. The

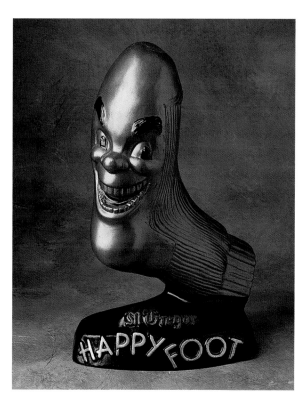

Happy Foot
*McGregor
athletic wear
1940s*

Happy Foot was used by McGregor to sell its athletic footwear. The character, however, was not a shoe but a grinning sock. The suggestion here was that McGregor shoes make your feet happy. The sock is a red herring. Perhaps advertising consultants thought that a naked foot was too risqué.

The most literal of all literal figures is a peculiar-looking little fellow named Rocky Taconite. Taconite is an ore that is mined for its iron content. While most literal advertising figurines are made of plastic, plaster, or papier-mâché, the Rocky figurines were actually made from taconite.

Literal figures are hybrids of human and product characteristics. The Master Lock Company's World's Strongest Padlock, for example, combines

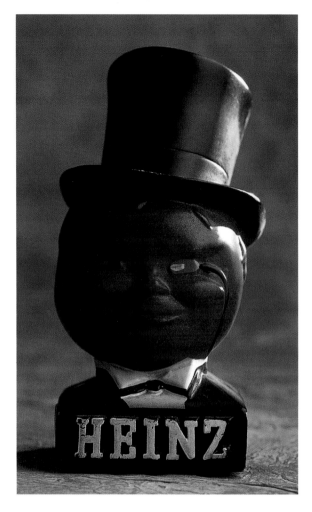

Aristocrat Tomato
Heinz tomato juice
1939

Karo Princess
Karo syrup
1919

Company. The company got its start in 1842 when Thomas Kingsford developed a method of separating the sugars and starches from milled corn, creating an inexpensive alternative to existing sugar and starch sources. In the early 1900s, the company did not bother with advertising. It did not need to. Its control over the cornstarch and corn syrup market was so complete that in 1916 the U.S. government brought an antitrust suit against the manufacturer, forcing it to allow more competition in the market. In early versions, the Karo Princess was more cartoonish and childlike. The only time she is ever seen these days is on the Argo cornstarch box.

Unlike human characters, literal characters show no signs of disappearing. They are as popular now as they were at the turn of the century. We are drawn to their unique looks and cheery personalities. Advertisers like them because they offer the best of both worlds: immediate identification and built-in product endorsements.

a strongman's body with a gigantic grinning padlock for a head. Although he was an appealing little fellow, the Padlock failed to make much of a splash in the world of advertising characters.

Another example is the Karo Princess who has the head of a Native American maiden and the body of an ear of corn. Since corn is native to America, the association is natural. The Karo Princess was created to advertise the Corn Products Refining

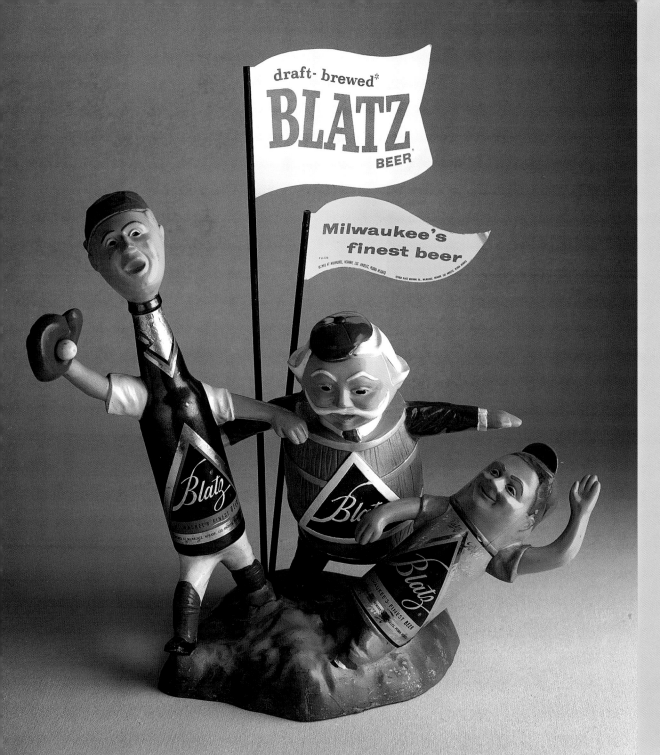

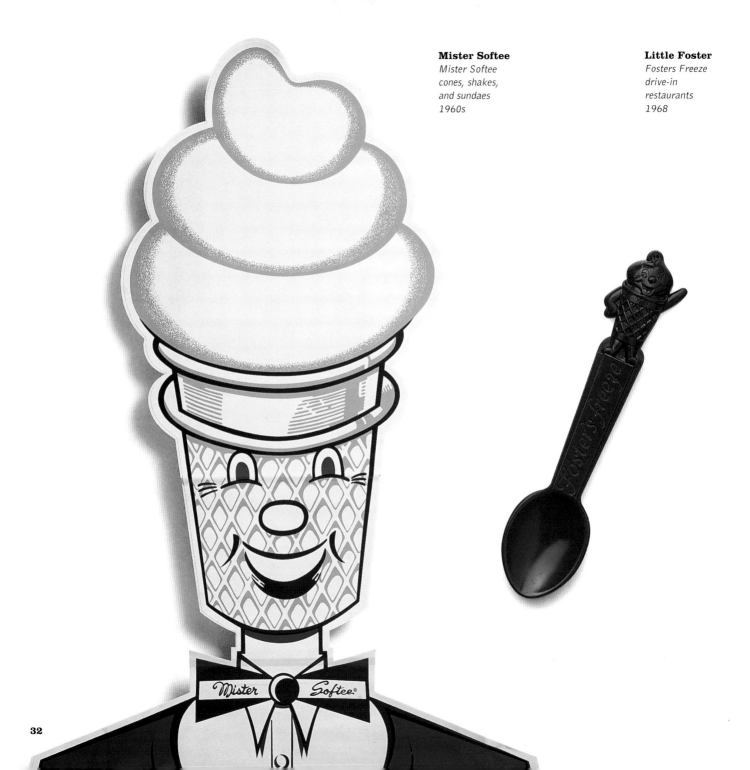

Mister Softee
*Mister Softee
cones, shakes,
and sundaes
1960s*

Little Foster
*Fosters Freeze
drive-in
restaurants
1968*

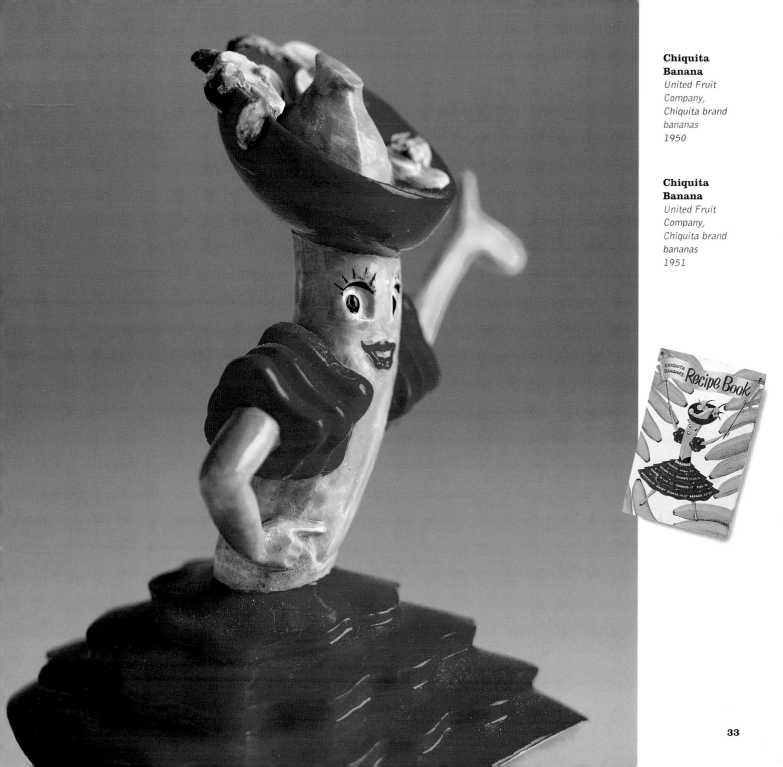

Chiquita Banana
United Fruit Company, Chiquita brand bananas
1950

Chiquita Banana
United Fruit Company, Chiquita brand bananas
1951

Funny Face
Pillsbury "Funny Face" soft drink mix
1967

Funny Face
Pillsbury "Funny Face" soft drink mix
1971

Kool-Aid Pitcher
Kool-Aid instant soft drink mix late 1960s

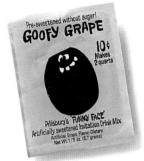
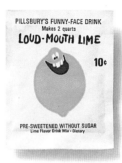
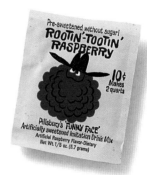

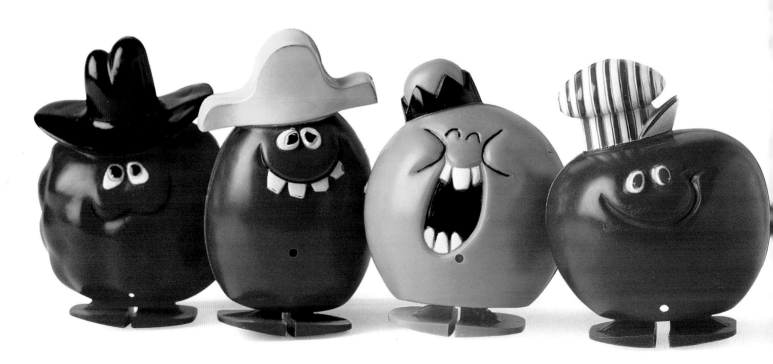

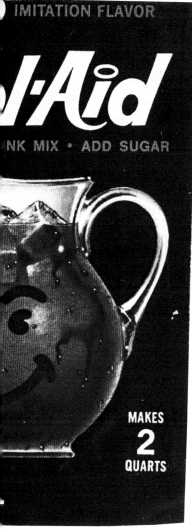
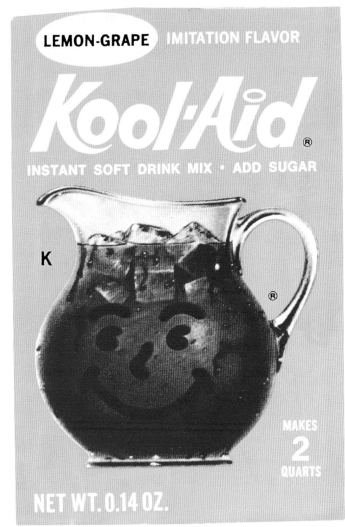
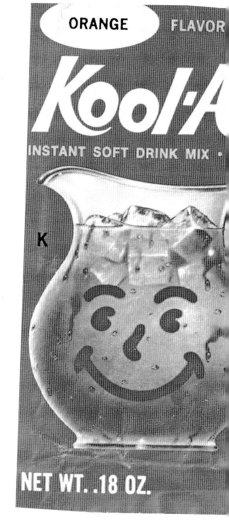

Michelin Man
Michelin tires
1981

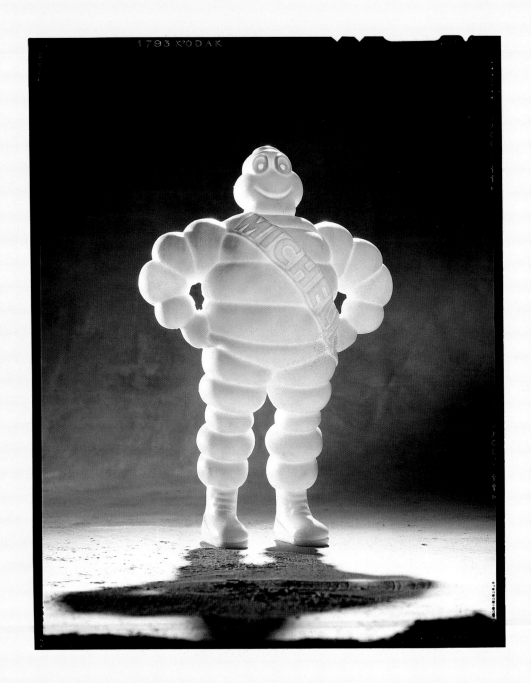

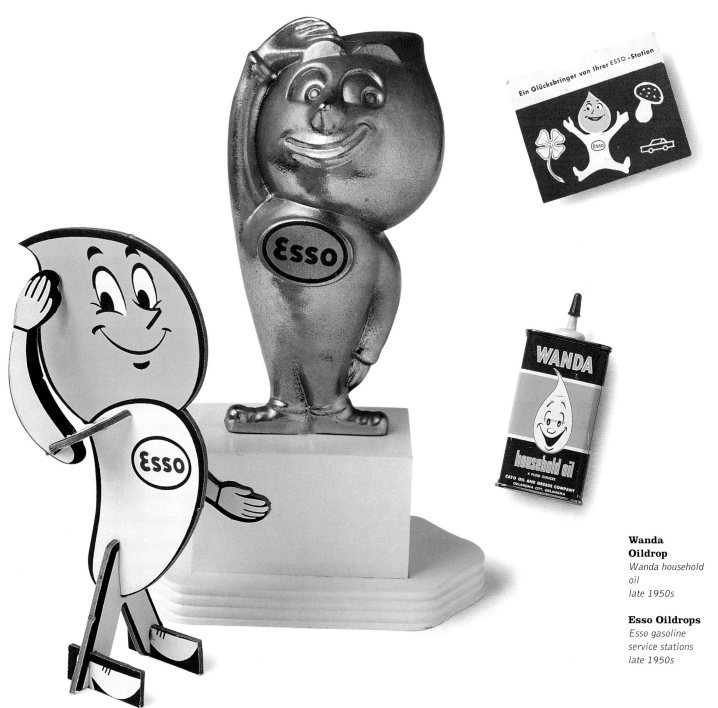

Ein Glücksbringer von Ihrer ESSO-Station

Wanda Oildrop
*Wanda household oil
late 1950s*

Esso Oildrops
*Esso gasoline service stations
late 1950s*

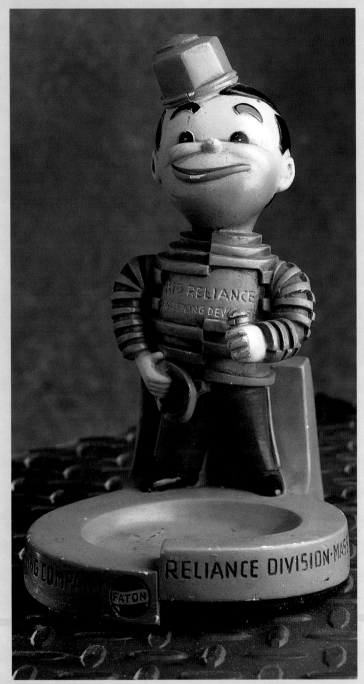

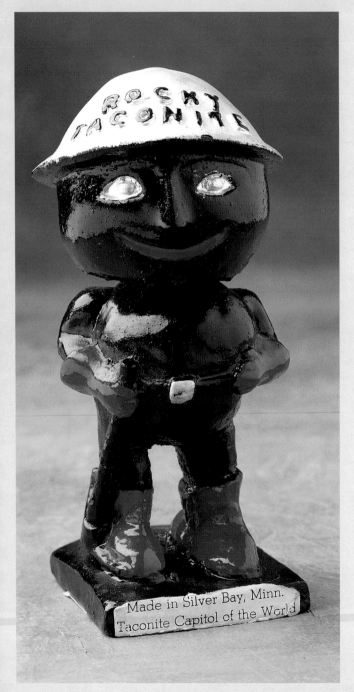

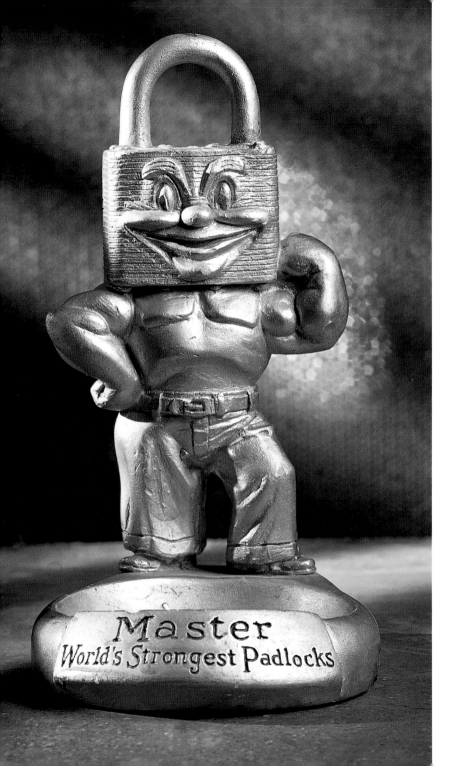

Kid Reliance
Eaton Manufacturing Company, Reliance division; fastening devices
1950s

Rocky Taconite
Silver Bay, Minnesota taconite industry promotion
1950s

World's Strongest Padlock
Master padlocks
1950s

Otto the Orkin Man
Orkin Exterminating Company
mid-1950s

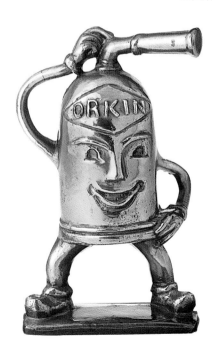

Animal Characters

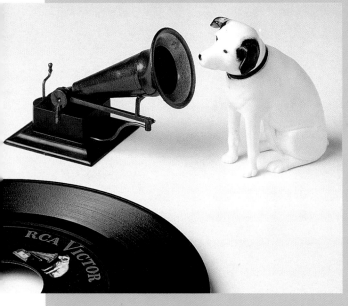

Nipper
RCA hi-fidelity products
late 1950s

As with human and literal characters, animals appeared in advertising from the start. They were chosen to represent products based on what the animals symbolically represented. Some connections are obvious and natural, as when polar bears are used to advertise cold products. Teddy Snow Crop, for example, was used to advertise Snow Crop's frozen orange juice. In native cultures, people have historically attributed to animals the embodiment of various spirits. This belief is called animism and is still practiced by advertisers. Sports teams still use animals as "mascots," who are supposed to bring the teams good luck. Few sports fans realize that the word mascot comes from the French word for sorcerer.

One of the oldest animal characters still in use is "Nipper." Nipper was a fox terrier that was adopted by an English painter named Francis Barroud when Barroud's brother—Nipper's original owner—died. According to the legend (although this story is probably apocryphal), at his former master's funeral the dog became enthralled with a phonograph recording of the dead man's voice. The animal looked into the horn of the phonograph, cocking his

head slightly, as if trying to figure out how his master was speaking to him from this strange device. Barroud had a brainstorm; he quickly painted the scene and submitted it to a phonograph company. When no interest was shown, he took the drawing to the Gramophone Company. It liked the painting, and had the artist change the phonograph (which in those days played cylinders) into a gramophone (which played 78 rpm records).

The Gramophone Company became the Victor Talking Machine Company, which was bought in 1929 by RCA. Nipper then became the trademark for RCA Victor. He has stood the test of time. Recently, the terrier appeared in commercials for RCA's ColorTrak televisions and video equipment, this time with his son, Chipper.

Nipper is by no means the only dog in advertising. People like and trust dogs, which makes them prime candidates for trademarks and logotypes. With so many different breeds to choose from, advertisers can choose the breed to match the image.

For the Mack Truck Company, the logo of the bulldog came about from the term given to its trucks in World War I. The snub-nosed hoods of the trucks and their stubborn ability to perform in the worst conditions led the British soldiers to call them "bulldogs." In 1922, the company officially adopted the animal as its advertising character. In 1932, A. F. Masury, the company's chief engineer, sculpted a blocky model of a bulldog out of soap while he was convalescing in a hospital. He was so smitten with his little bulldog that he decided to use it as the hood ornament on Mack trucks, where it is still in use today.

When we think of speed, we think of greyhounds, but it wasn't only the speed association that prompted Carl Wickman, the founder of the Greyhound Bus Company, to choose that animal as his icon. It was also the color. Back in 1914 when Wickman started his company, many of the roads across the country were still unpaved. Wickman owned a seven-passenger Hupmobile that he used to shuttle passengers between towns. Wickman had it painted a neutral battleship gray because anything else looked dirty after hours on the road. One day someone commented that the vehicle looked like a greyhound streaking down the road. Wickman immediately saw the potential. He renamed his company and adopted the slogan "Ride the Greyhound."

A bassett hound was used by the Wolverine Shoe Company to advertise its Hush Puppies line of soft-soled shoes. The term "hush puppies" came from the fried cornmeal biscuits traditionally served with catfish in the southern states. Originally they were made to give to dogs to keep them quiet while the folks ate their dinners; hence the name. Wolverine used the term to connote silence, implying that its shoes are very quiet.

A bassett hound well known to people on the East coast was Axelrod, the mascot for Flying 'A' Gasoline. Flying 'A' used the bassett hound because of its worried

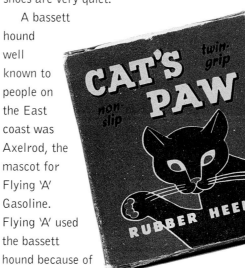

Cat's Paw
*Cat's Paw rubber heels
early 1950s*

Ken-L-Ration Dog
Ken-L-Ration dog food
late 1950s

expression. The slogan read: "When it comes to your car...Ooooh, do we worry!"

Bristol Laboratories used a coughing dog to advertise Naldecon-CX cough syrup, designed to eliminate "barking coughs." American Brake Shoe Company used a long-haired terrier named Stopper, shown in its advertising skidding to a stop. And of course there is Spuds McKenzie, whom we will discuss in more detail in the last chapter.

Cats are also used in advertising, but the human relationship with cats is quite different from the one shared with dogs. Many people still fear cats. While dogs have been domesticated for nearly twelve thousand years, cats are relative newcomers to the family home. It was the Egyptians who first domesticated felines four thousand years ago. Some people feel that cats are closer to the jungle than dogs.

During the Middle Ages, cats were believed to be agents of the Devil. Cats were hanged and immolated alongside their owners. Black cats were considered particularly unlucky, so much so that the superstition persists today. Ironically, it is the black cat that shows up most often in advertising. Cat's Paw rubber heels and Eveready batteries are two examples of companies that use black cats in its advertising. In the case of the Eveready Battery Company, the cat is used because of the old myth that cats have nine lives.

Birds are also popular with advertisers. They have been used to advertise everything from whiskey (Old Crow) to a nightclub (The Stork Club). They are especially popular for shoe products. Shoe companies named after birds include Red Goose Shoes, Weatherbird Shoes (which uses a colorful rooster), and Poll Parrot Shoes. Although it doesn't sell shoes, Kiwi Shoe Polish also uses the flightless bird for its trademark.

Eveready Cat
Eveready batteries
late 1950s

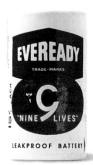

Owls are symbols of wisdom, in mythology and advertising. Minerva, the Roman goddess of wisdom, is portrayed with an owl on her shoulder. The Wise-Buy Owl used by Wards stores to advertise its Riverside tires is an example of this. The owl wears a service station attendant's cap and has a tire tucked under its wing. He also wears glasses, another symbol that is commonly associated with intelligence.

Penguins are a favorite with advertisers. They are the perfect balance between adorable and unusual. When an advertiser wants to convey a sense of cold or coolness, the penguin is used. The most famous penguin of all is Willie, used by the Brown & Williamson Tobacco Corporation to advertise its heavily mentholated Kool cigarettes. Willie was a hit with people. As with Aunt Jemima and Uncle Mose, Willie's mate, Millie, was introduced for the sake of salt and pepper shakers, although she did appear in some print ads. The penguin is also a natural choice to advertise frozen foods; hence the Swanson Penguin, used to advertise its line of TV dinners. Because of its tuxedolike markings, the penguin is the "dapper Dan" of the animal kingdom. For this

reason the Munsingwear Clothing Company uses the penguin to advertise its clothing line. A more obscure choice of the penguin is the Penguin Books logo, which was created to compete with the rival Albatross Book Company.

Chickens could almost qualify as literal figures. They are commonly used to advertise fried chicken restaurants. But you'll never see a cooked chicken used as an advertising character. We always see them before the fact: feathers still intact, smiling and laughing, unaware of their fates.

During the late fifties and early sixties, no chicken was better known than the one who sat atop Chicken Delight restaurants. He wore a chef's toque and held aloft a plate of biscuits with one wing. Chicken Delight restaurants spread across the country. "Don't cook tonight, call Chicken Delight!" became a well-known slogan. Due to stiff competition from Kentucky Fried Chicken and management problems, the Chicken Delight restaurants that once dotted the country are now only memories.

In a similar vein, the Jordan's Pig is a cheerful creature in blue overalls used by Jordan's Meats to advertise its meat products, which include pork.

Cows are used to advertise milk products. An endearing cow called Tillie of Tillamook is used to advertise Tillamook brand cheeses. Borden Incorporated introduced a whole lineup cows in 1936 as part of a series of print ads. But only one of the cows captured the public's imagination. Her name was Elsie.

In 1939, Elsie was singled out as the cow of choice for all of Borden's advertising. That same year, at the New York World's Fair, the popularity of Elsie was demonstrated amply to the Borden officials. The company prepared a modernistic exhibit featuring its new "rotolactor," a rotating milking platform. To determine the popularity of the exhibit, the company took a poll of the questions asked by fair attendees. At the end of the first month only 20 percent of the questions people asked were about the milking device. Sixty percent of the people wanted to know where Elsie was. The following year, Borden gave the public what it wanted. Borden found a cow named "You'll Do Lobelia" that fit its image of what Elsie should look like. The cow was the hit of the fair—so much so that Hollywood called, requesting the use of Elsie/Lobelia in the film *Little Women*. So as not to disappoint the fair-goers, Borden introduced Elsie's mate, Elmer, at this time.

Swanson Penguin and TV dinner
Swanson TV dinners 1970s and mid-1950s

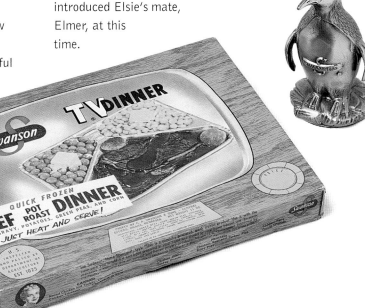

Sleepy Bear
*TraveLodge
motels
late 1950s*

**Playboy
Rabbit**
*The Playboy Club
late 1970s*

Elsie's bungalow was redecorated as a bachelor pad. Elmer was a hit as well.

For many years Elmer stayed in the background, an amusing adjunct to Elsie. When Borden started marketing a white glue made from milk by-products, it felt that Elsie was not a suitable choice for the advertisements. The glue advertising was turned over to Elmer, and the product was christened "Elmer's Glue."

Bears as advertising characters fall into two categories: real bears and teddy bears. Real bears are used like the Native American ad characters, to impart a sense of nature or naturalness to a product or campaign. Teddy bears are used for their cute cuddliness. An example of the first category is Smoky the Bear.

Teddy bears were introduced in 1902. They got their name from President Teddy Roosevelt after a trip he made to Mississippi. Roosevelt had expressed an interest in bear hunting while he was down South. The locals tried to help him by rounding up a bear for him to shoot, but the best they could find was a tiny cub. The president preferred larger prey and declined the offer. A cartoonist named Clifford Berryman drew an editorial cartoon of the event, and the picture of the little bear in the cartoon gave Rose and Morris Michtom of the Ideal Company the idea to create little toy bears dressed like Roosevelt. Teddy bears in advertising mainly represent comfort. The Sleepy Bear used by TraveLodge is an example of this. Since most people use motels as places to sleep, Sleepy Bear is also a clever representative of two

other aspects of the bear. Teddy bears are used by children to help them sleep, and the bear is associated with hibernation. A different sort of comfort is represented by Snuggles, the charming little bear used to advertise Snuggles Fabric Softener.

Most characters are carefully designed right at the start, but sometimes fate intervenes to create a new logo. When Hugh Hefner started working on his magazine, he planned to call it *Stag Party*. He hired cartoonist Arv Miller to draw a picture of a stag wearing a smoking jacket, standing next to the fireplace in a typical fifties bachelor pad. When *Stag* magazine got wind of his new publication, it threatened to sue. Hefner changed the name of his magazine to *Playboy* and had Arv Miller change the stag into a rabbit. Hefner decided that the debonair-looking mammal made a perfect advertising character for the magazine. Starting with issue number two the rabbit appeared on the cover of *Playboy*, and he has been on every cover since.

For no apparent reason, rabbits came to advertise two of the leading chocolate drink mixes. The first was the Bosco Rabbit. Bosco chocolate syrup was extremely popular in the fifties. The syrup came in a plastic container in the shape of a bunny. Although the product is still being marketed regionally, it is nowhere near as popular as it once was. A more endearing character is the Quik Bunny used to sell Nestlé's Quik chocolate drink mix. This sad-eyed character with huge floppy ears was an instant success.

An animal may be chosen to advertise a product for a host of reasons. The Gold Seal Company's mascot, Goldie the Seal, was the obvious result of a

pun. When the Kellogg Company asked Leo Burnett for a new character to advertise its new Cocoa Krispies, Burnett came up with the idea of using a monkey because his daughter had recently gotten a monkey as a pet. (Obviously the girl hadn't had the creature for very long, otherwise Burnett would have never suggested the animal; monkeys are notoriously nasty pets.) The Cocoa Krispies monkey continues to appear on boxes of the cereal, although his appearance has changed drastically since his introduction.

In 1960, General Mills introduced a new cereal called Twinkles. For advertising, it chose an orange elephant. Twinkles the Elephant was taken from a Saturday morning cartoon show called *King Leonardo and his Subjects*. The gimmick with Twinkles was that each cereal box had a little multipage storybook built into the back panel. Kids loved Twinkles, but they apparently loved the storybooks more. After the storybook boxes were discontinued Twinkles faded into oblivion.

Bigger than any elephant, and more successful than Twinkles, was Dino, the Sinclair dinosaur. Dino went against all marketing common sense. Dinosaurs were seen as large, ponderous creatures, not an association one would normally want with a product that is supposed to increase automotive performance. The folks at Sinclair didn't give a hoot about that. They liked the dinosaur and the fact that gasoline comes from fossil fuels. Dino was especially popular with children. Part of Sinclair's success was due, undoubtedly, to parents giving in to their kids' demands to stop at the station with the dinosaur.

Most adults didn't want a dinosaur, they wanted a tiger in their tank. And a tiger is just what Humble Gasoline offered. Tigers date back to 1913 as gasoline advertising icons. In 1959, the Oklahoma Oil Company started using the slogan "Put a Tiger in Your Tank!" By itself the phrase was clever but meaningless. When Humble Oil took the slogan and combined it with the cute cartoon tiger, the slogan and the tiger took off.

Animal characters are also used to identify products with certain places. Varig Airlines of Brazil uses a large-billed, toucanlike bird decked out in sunglasses and a straw hat; ready to hit the beaches in Rio, the bird is obviously South American, like the airline company. The best example of this is the koala bear used by Qantas Airlines. The koala is shown sitting in a tree, lamenting the impending onslaught of tourists attracted to Australia by the airline's low rates. The preternatural cuteness of the animal is perfectly matched with a Sad Sack voice. "I hate Qantas," the koala moans.

Animal characters are as popular now as they ever were. In this urban world we are so far removed from nature that even cows and chickens seem interesting and unusual.

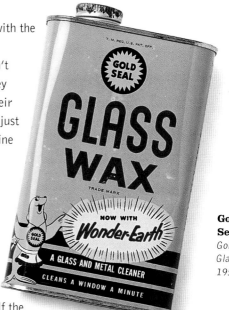

Goldie the Seal
Gold Seal Glass Wax 1952

José the Monkey
Kellogg's Cocoa Krispies cereal 1958

Trademark dogs: Axelrod
Flying 'A' gasoline service stations mid-1960s

Stopper
American Brakeblok safety brake linings 1970s

Barking Cough Dog
Naldecon-CX cough syrup 1970s

Hush Puppies
Hush Puppies shoes 1970s

Mack Bulldog
Mack trucks 1970s

Fetch and T-Bone
Fetch dog food and T-Bone dog biscuits early 1960s

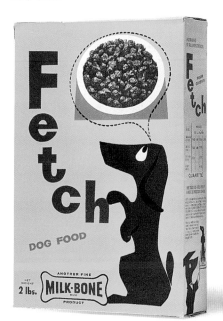

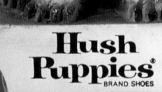

Hush
Puppies®
BRAND SHOES

When Barking Coughs
Accompany Colds...
NALDECON-CX®

MACK

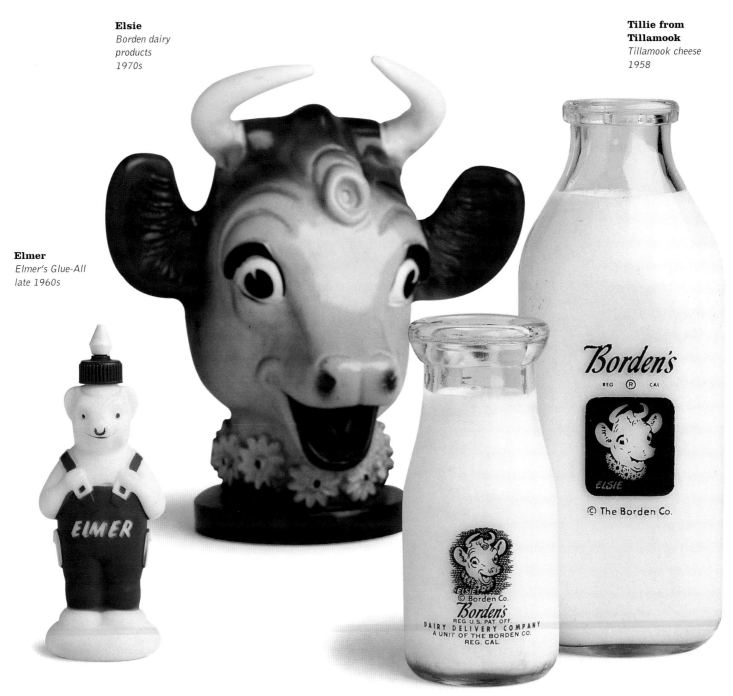

Elsie
*Borden dairy
products
1970s*

**Tillie from
Tillamook**
*Tillamook cheese
1958*

Elmer
*Elmer's Glue-All
late 1960s*

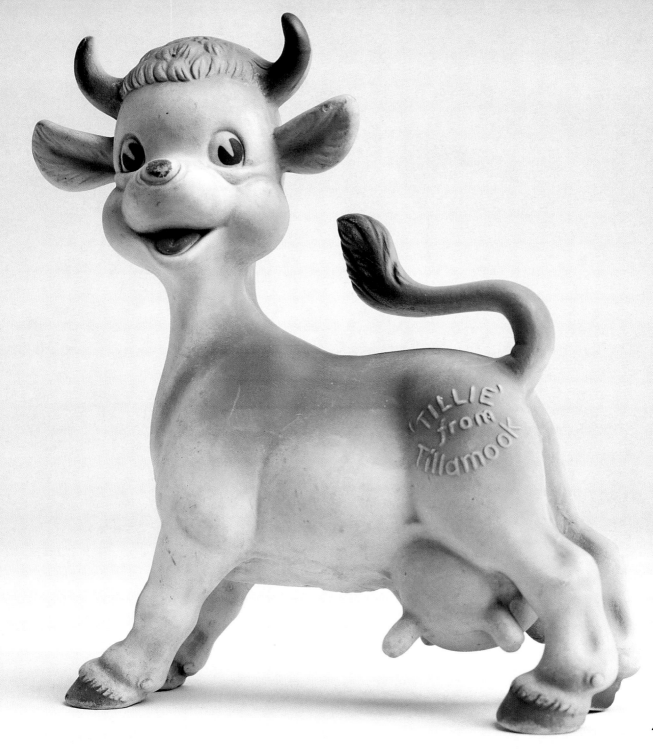

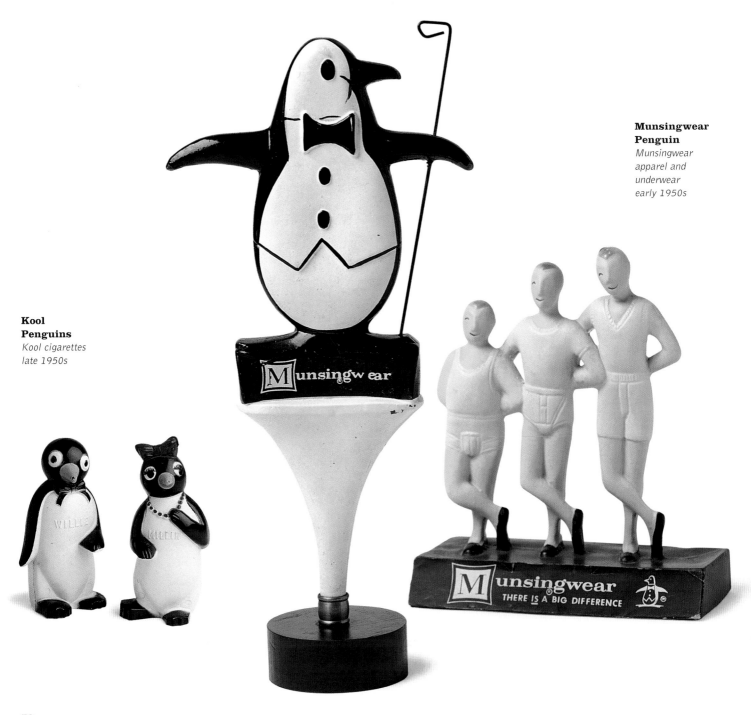

Munsingwear Penguin
Munsingwear apparel and underwear early 1950s

Kool Penguins
Kool cigarettes late 1950s

50

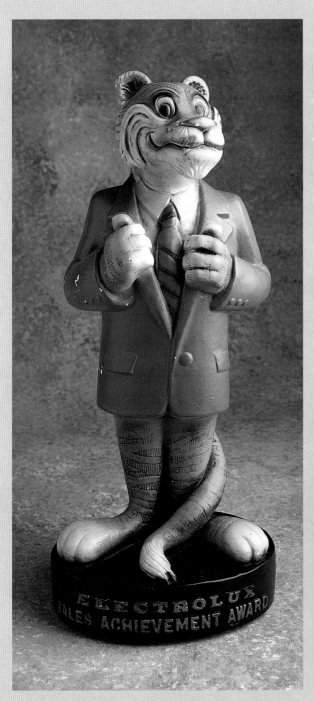

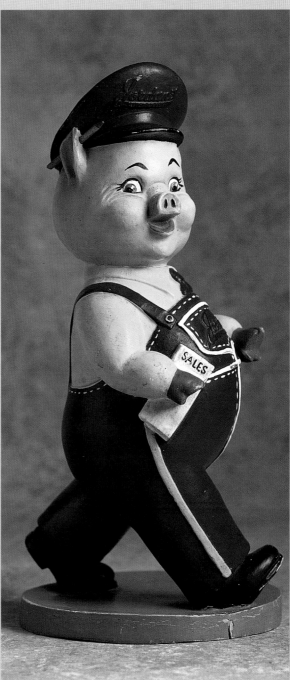

Electrolux Tiger
Electrolux vacuum cleaners mid-1960s

Jordan's Pig
Jordan's ready-to-eat meats late 1930s

Bosco Rabbit
*Bosco chocolate-
flavored syrup*
1960s

**Nestlé's Cow
(Germany)**
*Nestlé's Quik
chocolate drink
mix*
1970s

**Nestlé's
Rabbit**
*Nestlé's Quik
chocolate drink
mix*
1970s

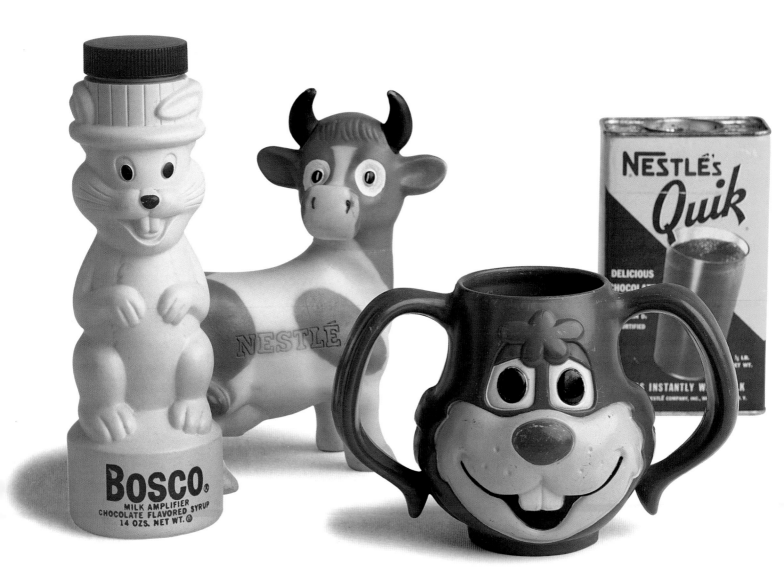

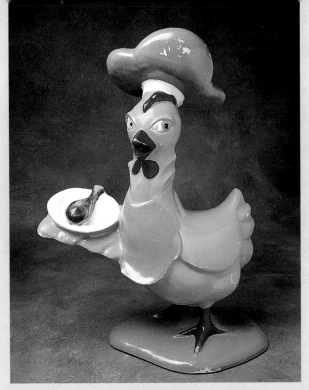

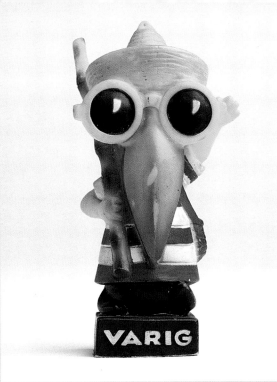

Chicken Delight
Chicken Delight take-out restaurants mid-1960s

Varig Bird (Brazil)
Varig Airlines 1970s

Wise-Buy Owl
Ward's Riverside tires 1970s

Teddy Snow Crop
Snow Crop frozen orange juice early 1960s

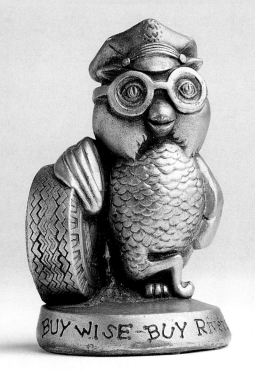

Pixies, Elves, and Other Magical Beings

Psyche
*White Rock
beverages
late 1950s*

At the turn of the century, architecture, interior design, fashion, painting, and jewelry design were all heavily influenced by the Art Nouveau movement. It was a style that used the asymmetrical, organic shapes of nature. Its indulgence and excesses were direct reactions to the restrictive attitudes of the Victorian era, which was just ending, and to the ever-growing pile of mass-produced, artless goods. Art Nouveau had its roots in the Symbolism movement, which celebrated the mythical and fantastic in the face of encroaching science and technology.

In America, the effects of Art Nouveau on design and fashion were less pronounced than in Europe. The style was considered too indulgent by us stodgy Yanks, but one side effect of the movement did make it into our mainstream—the magical creatures that the Nouveau artists and Symbolists so loved started showing up in our advertising.

The oldest and most obviously Nouveau of the magical advertising characters is Psyche, the White Rock nymph. Psyche got her start at the Chicago World's Fair in 1893. It was there that the owners of the White Rock Mineral Springs first saw *Psyche at Nature's Mirror*, a painting by German artist Paul Thurman. They convinced Thurman to let them buy the

painting and use it in its advertising. Psyche has appeared in numerous print ads throughout the century and is still in use today. As with Aunt Jemima and Betty Crocker, Psyche has changed her appearance over the years. Her hairstyle went from Teutonic maiden to Mary Pickford to the current style, which bears a strong resemblance to Tinkerbell's coif. She has also lost some girth (mostly around the hips), and she's grown four inches taller.

The most common magical beings used in advertising belong to the group referred to as the "little people." These include pixies, elves, fairies, and leprechauns. Fairies were extremely popular at the turn of the century. "Have you a little fairy in your house?" was Fairy Hand Soap's slogan, taken from a popular song of the day. Today, fairies are seldom used. They remain the best representatives of Art Nouveau.

When people got tired of fairies, other types of pixies started turning up as advertising characters. In 1915, the Wrigley Gum Company introduced "Spearman," an impish creature who first showed up in a booklet of children's rhymes that Wrigley's had printed to publicize its chewing gum. The rhymes were variations on familiar Mother Goose stories but with lyrics pushing Wrigley's products. For example: "Pat-a-cake, pat-a-cake, candy man, buy Wrigley's Spearmint as fast as you can!"

In his original incarnation, Spearman was little more than a long, broad arrow with a face. Later on he became more of a literal character, with a body made of a piece of Wrigley's Spearmint gum. In 1969, Wrigley's finally retired the character.

Stokely Van Kamp, the company best known for its canned pork and beans, used a pixie named Easy to advertise its products. Like Wrigley's pixie, Easy's body consisted of the Stokely Van Kamp logo. He wore a hat that made him look like a drum major. Although charming, Easy did not make much of a splash in the advertising field and he is no longer in use.

Fairies and pixies are carefree and happy spirits, who would just as soon drift around on a lily pad as work. Elves, on the other hand, are the worker bees of the magical kingdom. For this reason they are still favored by advertisers. Snap!, Crackle!, and Pop! are among the best-known elves. This threesome got its start in 1933 when Snap! first appeared on the sides of Rice Krispies boxes. He was Kellogg's first advertising character, but by no means its last. A couple of years later, Snap! was joined by Crackle! and Pop! and the famous trio was formed.

Equally well known and as popular as Snap!, Crackle!, and Pop! are the Keebler elves. Prior to

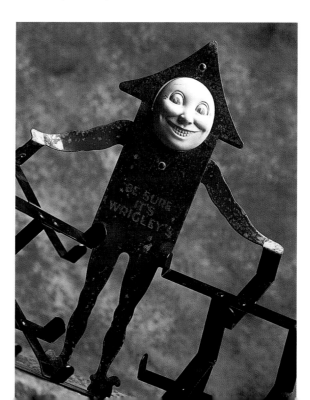

Wrigley Spearman
Wrigley's Spearmint gum 1930s

1966, the United Biscuit Company sold its cookies under different brand names all across the country. Following Exxon's lead, United Biscuit decided to consolidate all of these brands under one common name. It chose Keebler, after Godfrey Keebler, one of the bakers who founded the United Biscuit Company. The company hired the Leo Burnett advertising agency to come up with a campaign that would help it compete against Nabisco, the giant in the industry. Burnett's team came up with the Keebler elves. In the first commercials, the head elf was a stuffy fellow named J. J. Keebler. He was followed, briefly, by a lackadaisical character named Ollie. Finally the ad writers came up with Ernie, a charmingly sincere elf who has headed the Keebler lineup ever since.

Other, lesser-known elves include the Siedlitz Paint Elf and Magic Marxie, who advertises Marx Toys.

Among the elfin folk, the leprechaun is most closely associated with Lucky Charms cereal. L. C. Leprechaun (known as Lucky to most people) was introduced in 1964. Over the years, Lucky's appearance has changed, but the changes have been introduced so carefully and slowly that they are unnoticeable unless you compare the early character side by side with later versions.

Occasionally, advertisers move away from the lovable and turn to the demonic. Devils and demons, while less common than the ingratiating elfin folk, have turned up as advertising characters from time to time. Little Devil, who appears on tins of Underwood deviled ham, is the best known. Hotpoint appliances also used a devil as an ad character. This smiling character's resemblance to a devil was minimal. He wore a red suit, but his large eyes and prominent cheeks made him resemble a ventriloquist's dummy more than one of Satan's minions.

The American Furnace Company has used a character called BTUdee that falls somewhere between imp and pixie. This smiling fellow has the pointed ears of a pixie, but his hair is a red mass of flames. As with some other pixie-type characters, his body is replaced with the company's logo.

Elfin creatures are not only found in the West. When Trader Vic's decided to use a pixie to advertise its restaurants, it chose the Menehune, a mythical race of little people who supposedly inhabit the Hawaiian islands. Legend has it that the Menehune only come out at night. They work together in great numbers, building walls and roads before the sun comes up.

Mythical creatures in advertising aren't limited to the little people. Giants are also used. We are all familiar with the Jolly Green Giant. This smiling, verdant fellow got his start as a brutish-looking creature holding a giant pod of peas. The character was created when Pillsbury discovered that it could not trademark the name Green Giant Peas. Pillsbury had developed a new variety of large peas that tasted as good as the popular smaller peas. It called them Green Giants, but when it tried to copyright the name the government ruled that Green Giant was a description, not a trademark. To get around this, it created the big fellow.

The original giant was adapted from a picture of an ogre in a book of Grimm's fairy tales. When a

Menehune
Trader Vic's restaurant late 1970s

former Pillsbury employee named Leo Burnett started his own advertising firm, he took over the advertising accounts for the company. Burnett decided that the giant lacked pizzazz, so he added the word "Jolly" to its name and improved the big fellow's looks, creating the character that we are familiar with today.

Since advertising characters are often manufactured as miniature figurines, designers use clever techniques to create the illusion of size. With Rocky, of Rockwell Transmission and Axles, the illusion of size is created by the foreshortening of his legs and the exaggeration of his torso. The same technique was used by Allstate Tire Company to create its Mr. Allstate character.

Although Paul Bunyan is not considered an advertising character, he was virtually unknown outside of the lumber camps until the Red River Lumber Company started using him in its advertising. He first cropped up in the camps when loggers, trying to entertain themselves, used the character to spin tall tales. The Red River Lumber Company incorporated him into its advertising and printed booklets chronicling the adventures of the giant lumberjack. Paul Bunyan became part of the American landscape largely thanks to the company's efforts.

Another character who got his start as a fictional character but has since become part of our collective mythology is Peter Pan. The eternal boy first appeared in a play written by James Barrie; later it was turned into a book and a musical. The play was extremely popular, but it is the Walt Disney movie that introduced the current generations to the character. Later on, the Derby Food company decided to use the character as the salesperson for its peanut butter.

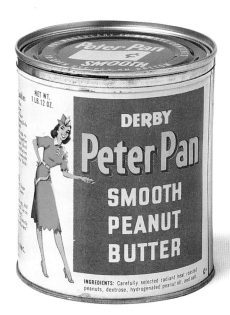

Peter Pan
Peter Pan peanut butter
late 1950s

Occasionally actual mythological characters are used in advertising, but this occurs less often than you might think. Apparently advertisers are reluctant to trust the power of Zeus to sell its goods. One famous and notable exception is Pegasus, the winged horse used by Mobil Oil Company. Pegasus got its start as an advertising character in 1911 in South Africa, where the Vacuum Oil Company used it to advertise premium gasoline. When Vacuum Oil merged with the Socony Oil Company, Pegasus was introduced in America.

Magical characters are also used whenever advertisers want to suggest that its products are capable of magic. This is the idea behind Mr. Clean, the genie in the glass bottle who will help you clean your house without the usual amount of labor. Created for Proctor & Gamble, Mr. Clean is an amalgam; a cross between a sailor and a genie. At the time of his introduction, a product called Lestoil

Pegasus
*Mobil gasoline
service stations
late 1930s*

was the most popular liquid cleaning product on the market. Mr. Clean was designed to knock Lestoil out of first place, which he did effortlessly. Later on, Mr. Clean faced stiffer competition when Ajax introduced its White Knight. Something of a magical character in his own right, the White Knight was shown charging down the streets of suburban America, zapping away dirt with his lance to the chanted slogan "stronger than dirt!"

Wizards, although they are human, have a connection to the magical world. Advertising's wizards, however, are not the dour alchemical researchers of medieval times. You'll find little in common between Nostradamus and Wizard of O's, who advertised Franco-American Spaghetti-Os in the mid-seventies. Wizards in advertising are elflike characters, their apparel based on the stereotype so well portrayed in Disney's *Fantasia*: a long robe, pointed cap, and a magic wand.

When the Facit Company decided to use a wizard as its mascot, it abandoned the robe in favor of a more modern jumpsuit. Facit's choice of the wizard is a casebook example of how to advertise. Ivan Hammer, the company's advertising manager, noticed that most of Facit's competitors took a conservative and businesslike approach to advertising. Hammer decided to abandon that approach and have some fun. The Facit Wizard first appeared in the instruction manual that was included with Facit's calculators. This was back in the fifties and sixties, before calculators became something you could buy at the check-out stand in Walgreen's. Calculators were bulky things that ran on wall current. A calculator that could add, subtract, multiply, and divide might set you back a hundred dollars or more.

Similar to wizards, in advertising terms, are clowns. Like wizards, they are humans who bridge the gap between the real and the fantastic. Advertising clowns are often endowed with magical powers, such as Ronald McDonald's ability to create windows and doors with a few hand gestures. Clowns have been used to sell everything from PEZ candy to Sugar Smacks cereal. Two well-known clown characters are Scoopy, who appears on Safe-T Pacific Company's boxes of ice cream cones and flexible straws, and Kedso the Clown, used by the United States Rubber Company to advertise its Keds brand of children's sneakers.

Humans have a funny, sometimes uncomfortable, history with magic. Our scientific side may scoff at the idea, while our romantic side says why not. History records the battle between these two sides. During the fifties it looked as if science had finally won, but an interest in magic resurfaced in the sixties as part of the hippie movement's rebellion against technology and the status quo. Currently there is a vogue for combining science and mysticism, with the accent on the scientific. Magical characters are in a slump, but there is no reason not to believe that they will again become popular someday.

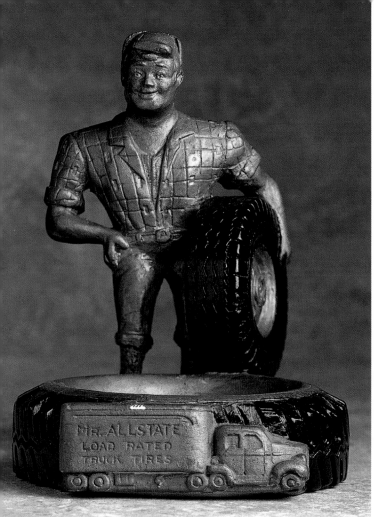

Mr. Allstate
Allstate truck tires
1950s

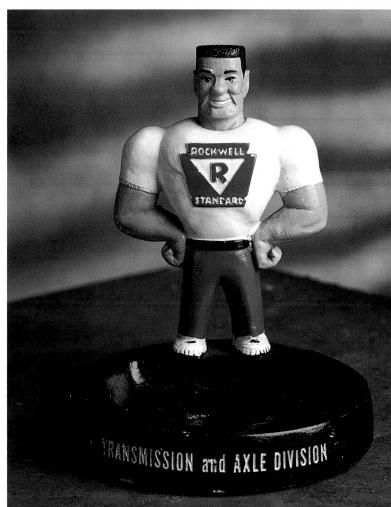

Rocky
*Rockwell
Standard
Transmission and
Axle Division
1950s*

BTUdee
*American
Furnace Company
1950s*

**Hotpoint
Devil**
*Hotpoint
appliances
1935*

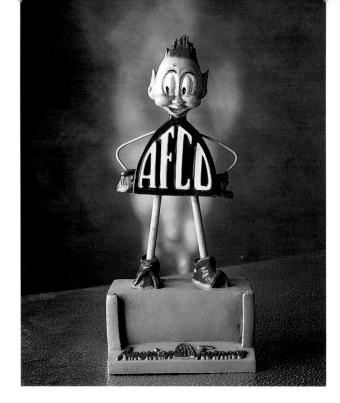

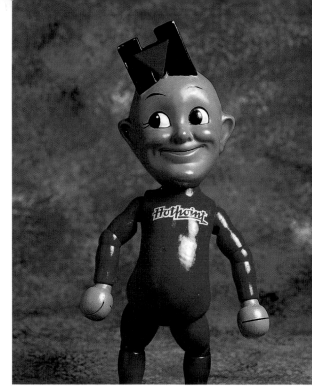

Facit Wizard
*Facit adding
machines and
calculators
late 1960s*

Paul Bunyan
*Red River
Lumber Company
1930s*

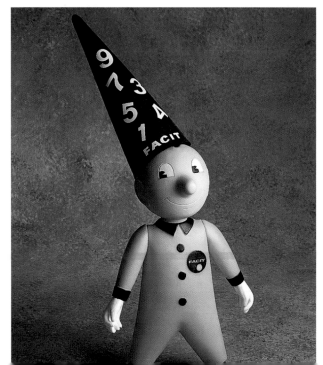

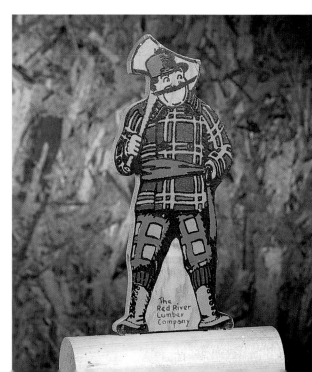

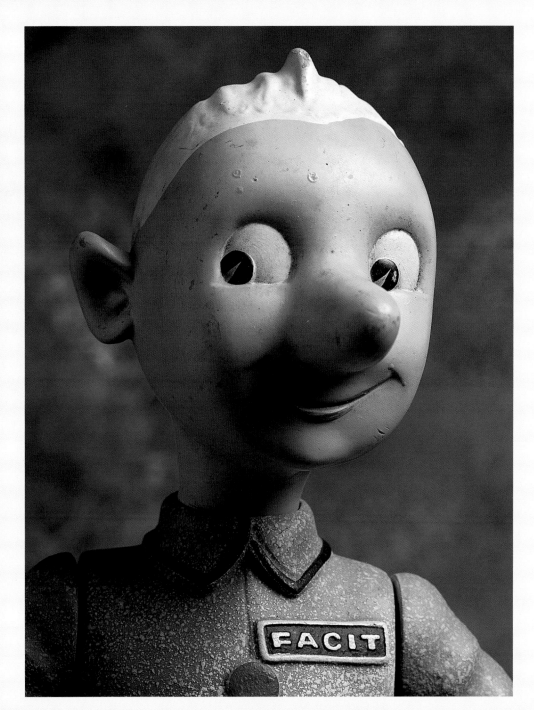

Facit Wizard
Facit adding machines and calculators late 1950s

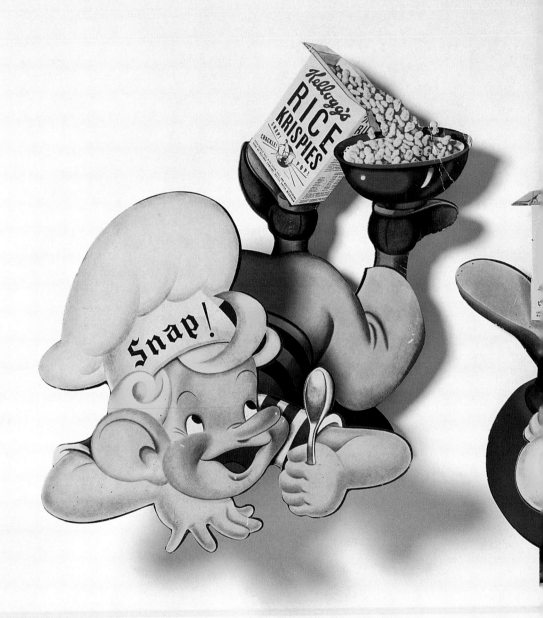

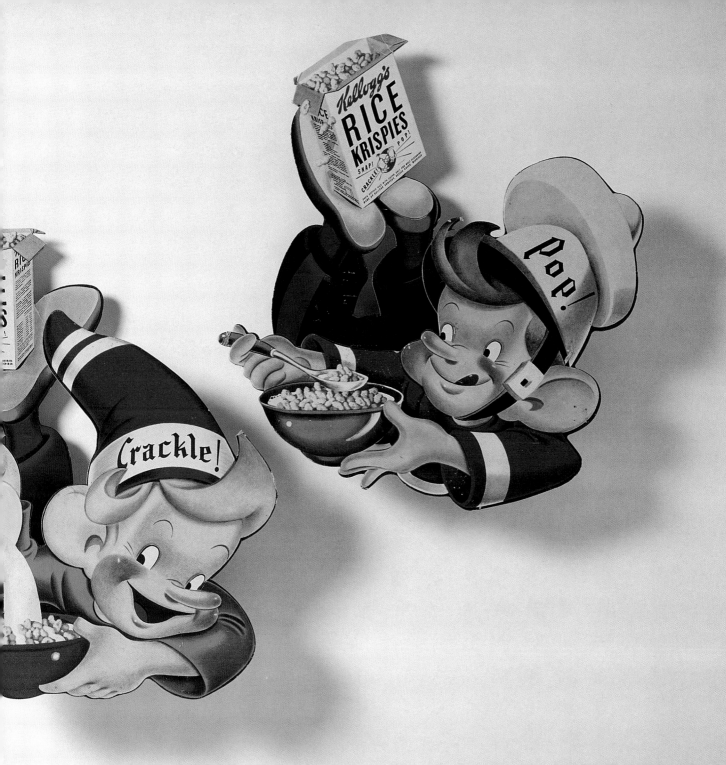

Peter PEZ
*PEZ candy
late 1960s*

Mr. Clean
*Mr. Clean all-
purpose cleanser
1961*

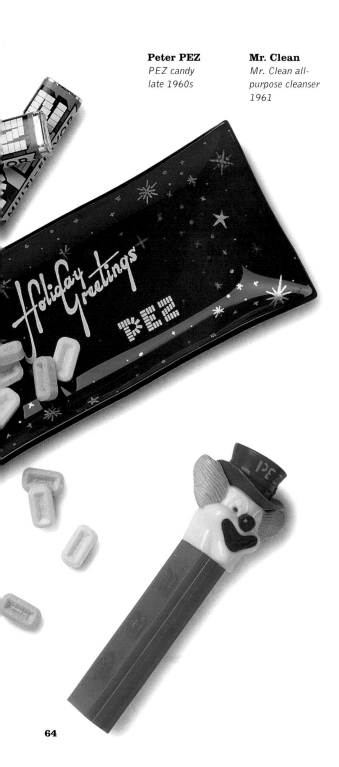

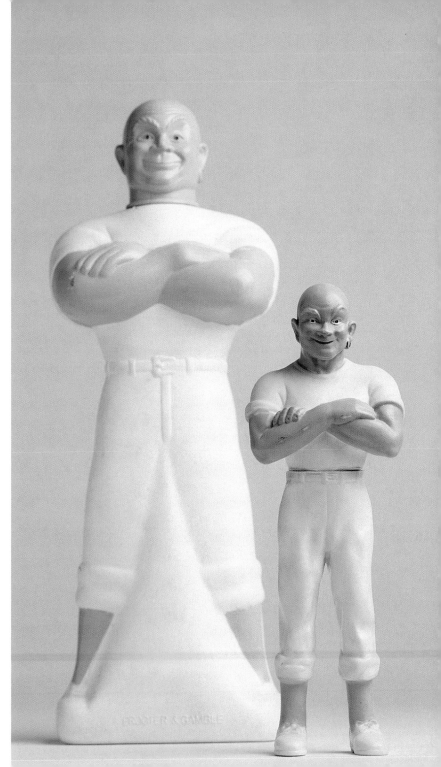

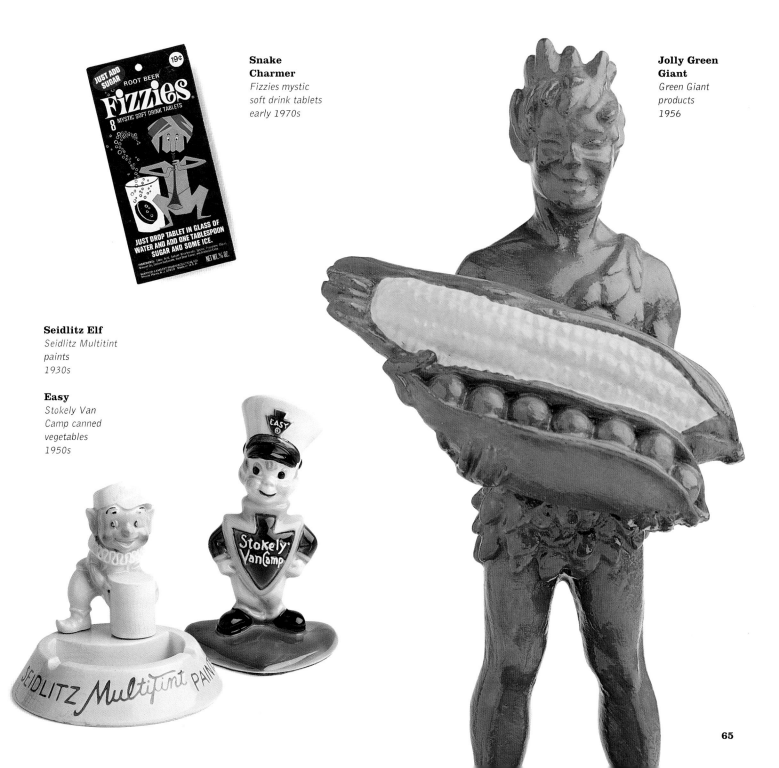

Snake Charmer
Fizzies mystic soft drink tablets early 1970s

Jolly Green Giant
Green Giant products 1956

Seidlitz Elf
Seidlitz Multitint paints 1930s

Easy
Stokely Van Camp canned vegetables 1950s

Futurism Comes to Advertising

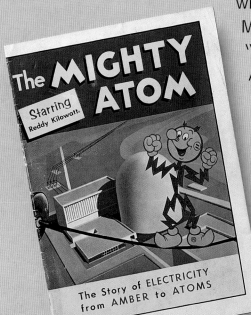

Reddy Kilowatt
Reddy Kilowatt, Inc. utility company promotions 1963

In 1909, the French newspaper Le Figaro reprinted an art manifesto written by Italian poet Emilio Filippo Tommaso Marinetti. Marinetti called for a new movement, which he labeled "Futurism." In style and ideology it was the apotheosis of Art Nouveau. Art Nouveau celebrated mysticism and magic, while Futurism celebrated science and technology. Nouveau was based on the fluid and organic shapes of nature; Futurism, on the other hand, preferred the geometries of Cubism and machinery. Together with a young painter named Umberto Boccioni, Marinetti sent shock waves through the art world.

As a movement Futurism fell apart during World War I, when Marinetti became a fascist and Boccioni became a corpse, but not before it helped spawn a dozen similar movements. In England, Wyndham Lewis introduced Vorticism, which like Futurism celebrated the modern. While futurists were fascinated by speed and electricity, Vorticists were more interested in their implied aesthetics: the sleek and mathematical planes of technology. Architecture and fashion also adopted these new outlooks with styles of their own. It was a time

when all artists and designers seemed to have catchy names for their artistic styles. A new "movement" sprang up every day—Rayonism, Orphism, Dadaism, to name a few. In architecture the new styles were called streamlined, jazz pattern, and art Moderne. In the 1960s, these various factions were lumped together under the heading of Art Deco, named after the 1925 Exposition Internationale des Art Décoratifs et Industriels Modernes, which was the first attempt to consolidate the various modern styles in one exhibition. But at the heart of Art Deco was Marinetti's concept of Futurism.

Just as Art Nouveau affected advertising, so did Futurism. Unlike Nouveau, which had its origins in old European ideas and aesthetics, Futurism was readily accepted by Americans, who were enthralled by science and technology and were far more ready to accept the changes that modernity brought to civilization. As technology advanced, interest in modernistic and futuristic subjects increased. The recurring themes of futurist advertising were speed, electricity, and science fiction.

Electricity, the life blood of the modern world, was supremely represented by that classic advertising character Reddy Kilowatt. Reddy Kilowatt was designed in 1926 by Ashton B. Collins, who was working for the Alabama Power Company at the time. Collins got the inspiration for the character during a particularly nasty thunderstorm. He imagined a character made out of bolts of lightning. Realizing the archetypal perfection of his creation, Collins left the Alabama Power Company and started his own company in 1934. The Reddy Kilowatt Service, as it was named, was exclusively devoted to power-company public relations. No one needed public relations service more than the power

companies of America. They were considered by most Americans to be the devil incarnate, powerful giants that were beyond the reaches of government or law, an attitude that still prevails.

Reddy was the perfect spokesperson. His friendly appearance gave the power companies a likable diplomat. Soon he appeared on electricity bills across the nation, reminding people to pay their gas and electric bills. The cynical subtext was lost on most people, who found Reddy cute without stopping to think that nothing had really changed.

A similar character (although he comes closer to being a literal figure than Reddy) is Willie Wiredhand. Willie was created in 1950. Like Reddy, he was used to help promote rural power companies.

Mr. Controls
Robertshaw-Fulton Controls Company appliance thermostat makers 1954

In 1957, Reddy Kilowatt took Willie Wiredhand to court on a charge of copyright infringement. The courts ruled against the folks at the Reddy Kilowatt Company, allowing Willie to continue his campaign.

Willie Wiredhand and Reddy Kilowatt demonstrate that literal figures created from the products of technology are inherently futuristic as well. Robertshaw's Mr. Controls is another example of this. The Robertshaw Company was started in 1907 by Frederick W. Robertshaw, inventor of the first water heater thermostat. The company went without a mascot for years, until the early fifties when Mr. Controls was officially adopted as the company's logotype. Made up of a dial, spring, knob, and bellows, Mr. Controls is certainly a literal figure, but he looks extremely futuristic. Another more obscure character is Mike Farad, the Philco transistor man made up entirely of resistors, transistors, and wire. Mike Farad was not sold to the general public as a premium but did turn up in stores, usually on the counter next to the cash register.

In 1923, when Karel Capek's play *R.U.R.* (which stands for *Rossum's Universal Robots*) was translated into English, the word "robot," which means "worker" in Czech, was left untranslated. The play was about workers, but not the ordinary flesh and blood variety. The workers in Capek's play were made of metal. Ever since, we have used the word robot to refer to mechanical laborers. Although mechanical people appeared in stories prior to the Capek play (L. Frank Baum's Tin Man of Oz, for a perfect example), *R.U.R.* came at a time when interest in the future was at its peak. With technology and science advancing by leaps and bounds nearly every day, people were optimistic that they would be around to see the futures that were described in science fiction stories. Robots quickly captured the imagination. In 1926, the German director Fritz Lang gave us the impressive Maria robot in his classic film *Metropolis*. Robots were also popular with advertisers, from the startlingly weird Westinghouse Robot, used to advertise automotive air brakes, to the likable little caricature of a robot that Seiko used in its store displays.

Although he is apparently a robot, The Iron Fireman owes as much to Baum's Tin Man as he does to *Metropolis*. This charming character was used by the Iron Fireman Company to help advertise its furnaces. The implication was that its furnaces were so low maintenance they seemed as if they had lives of their own.

An example of a robot who is also a literal figure is NAT, National Screw and Manufacturing Company's little robot. Except for the wooden ball that forms his head, NAT is entirely made up of the company's nuts, bolts, and screws. Interstate Brick's man of bricks is another literal figure. Although there is nothing inherently futuristic about bricks, his appearance is strikingly robotlike. He also

resembles a Cubist version of the Golem.

Sometimes the influence of Futurism is more appearance than technology. There is nothing inherently futuristic about the Kraft Cameraman—just a man doing his job; but the design of the character is so stylized and geometric that he easily fits the definition of a futuristic advertising character. Oddly, the character was not designed with logotype status in mind. Originally he was used in the opening credits for the *Kraft Television Theatre*. He proved so popular that the Kraft Company eventually created a plastic statuette of the character, which it sold as a premium during the fifties.

The Alcoa Strongman has the arms and head of a typical muscle-man icon, but in place of his body is the double-triangle logo of Alcoa aluminum. If the character had had a normal body he would have been less interesting, just another example of the strongman stereotype.

Vorticism's influence is readily apparent in the HIS cologne and talc bottles created by The House For Men, Incorporated. The bottles are shaped like a stylized human torso, while the cap is a futuristic rendition of a human head.

Similarly futuristic is Micronex Tread Mike, from an English tire company. Mike is a literal figure in the sense that his body is made out of a tire, but he bears no resemblance to Bibendum. His head is a black ball with a triangular swatch across it and two circles for eyes.

One danger of futuristic design is in its cold geometry, which does not lend itself to warm and friendly characters. Some clever advertisers, however, did manage to soften the images just enough. Tech, the Chrysler Corporation's friendly sphere-headed character, is an example. Although he was not known to the general public, Tech appeared on awards and premiums given out by Chrysler to its employees.

A trait common to several futuristic ad characters is the spherical head. Along with the Kraft Cameraman, Micronex Tread Mike, and Tech, the Konica Robot from Germany share this trait. Instead of a face, the Konica Robot has one large eye placed slightly off center on its head. During the fifties, space-age design moved away from the styles of Futurism and Vorticism. It incorporated the kidney and boomerang shapes and the vivid color schemes of Googie, as well as other popular design elements of the fifties. It is a style that is commonly associated with the TV cartoon show

Alcoa Strongman
Alcoa Wrap aluminum foil 1959

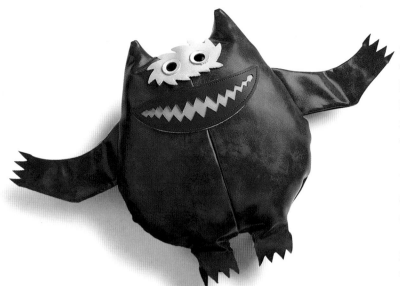

Nauga
*Uniroyal's
Naugahyde
1967*

**Westinghouse
Robot**
*Westinghouse
automotive air
brakes
late 1930s*

The Jetsons (although the style appeared in fifties advertising, well before the introduction of the Jetsons in 1963). This was a more playful vision of the future and suited advertisers well.

In the thirties, magazines dedicated exclusively to science fiction cropped up by the dozens. By the fifties, much of this fiction appeared to be headed toward realization. After Russia successfully put Sputnik into orbit, America went space crazy.

In his book *The War of the Worlds,* English author H. G. Wells introduced most people to the concept of extraterrestrial life (although others had speculated on this long before Wells had). During the fifties, dozens of films about the alien creatures were made, from the sublime (*The Day the Earth Stood Still*) to the silly (*Cat Women of the Moon*). It was natural, then, for advertisers to turn to space creatures to advertise their products.

Some of the first (and best remembered by baby boomers) are the Spoonmen—Crunchy, Munchy, and Spoonsize—for Nabisco's Shredded Wheat Juniors cereal. The three characters wore helmets shaped like the Nabisco trademark symbol, and their outfits resembled those of a high school marching band. In their original form, the Spoonmen were designed to hook onto the handle of your spoon while you ate breakfast. When the premium inside changed, the Spoonmen remained as advertising characters for the cereal.

The Spoonmen were designed by John C. "Wally" Walworth, Jr., a Hollywood cartoonist and animator who left the movie business in 1945 to design toy premiums for breakfast cereals and Cracker Jack. Walworth became one of the most prolific designers of premiums during the fifties, and every child of that decade who ever found a surprise in a box of cereal certainly encountered the handiwork of Wally Walworth.

The Jetsonian style disappeared in this country in the late sixties, replaced by English Mod and psychedelic fashions. In Japan, on the other hand, it is still popular. As with many things, the Japanese have taken the style, reshaped it, and made it their own. A beautiful example of this is the Denon Astrogirl used by the Denon Company to advertise its hi-fi equipment. The Denon Astrogirl is a green-haired maiden wearing a silver space helmet and an orange leotard. She sits astride an asteroid inscribed with the Denon name. Japanese futurism appears everywhere and has started filtering back into our society in the form of kids' toys and TV shows—the Transformers are a perfect example of this.

Futurism is one of the most fun categories in advertising, but its heyday appears to be over. Our once idyllic visions of the future have been destroyed by the prevailing attitude that whatever the future may bring, it probably won't include trips to Mars and robot butlers.

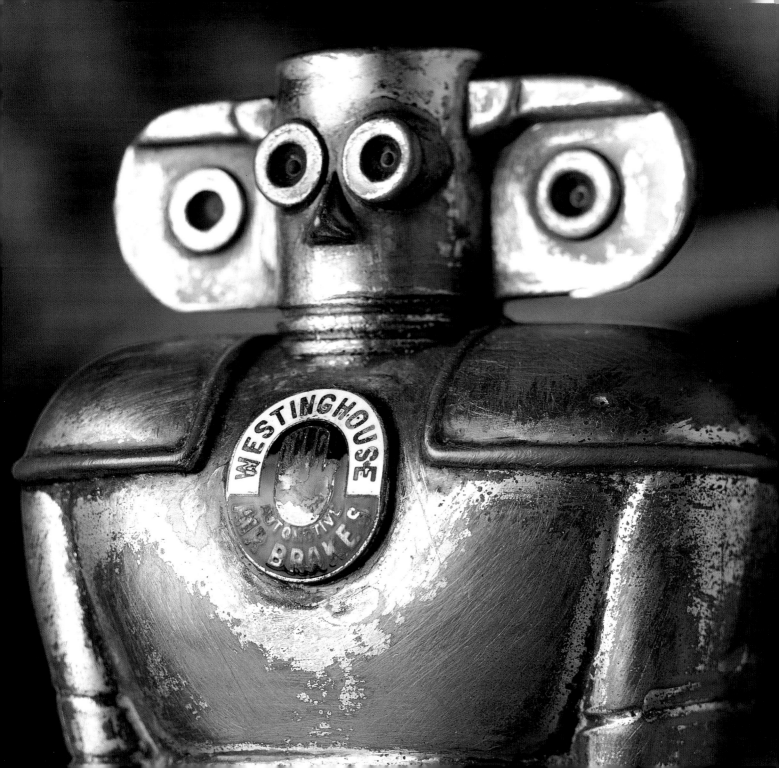

Seiko Robot
Seiko watches
1977

Iron Fireman
Iron Fireman
furnaces
1930s

Mr. Brick
Interstate Brick
Company
1950s

Mity Mike
KMO, "The Voice
of Tacoma" radio
station
1930s

**Konica Robot
(German)**
Konica-Braun
SLR cameras
1970s

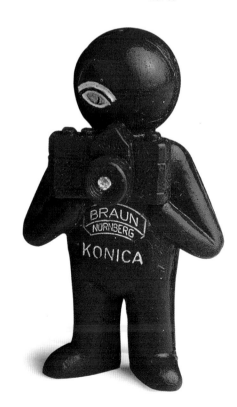

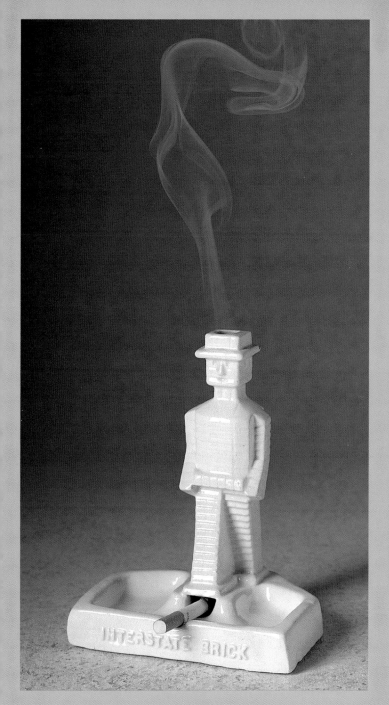

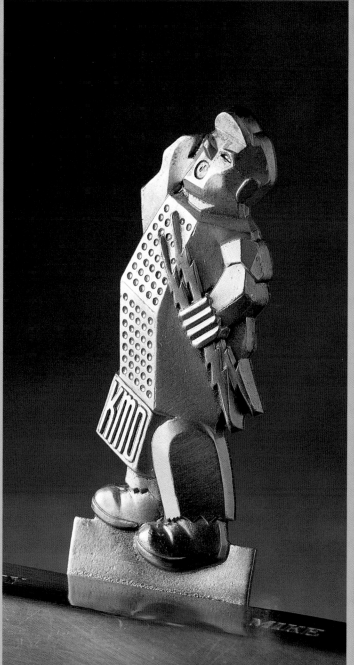

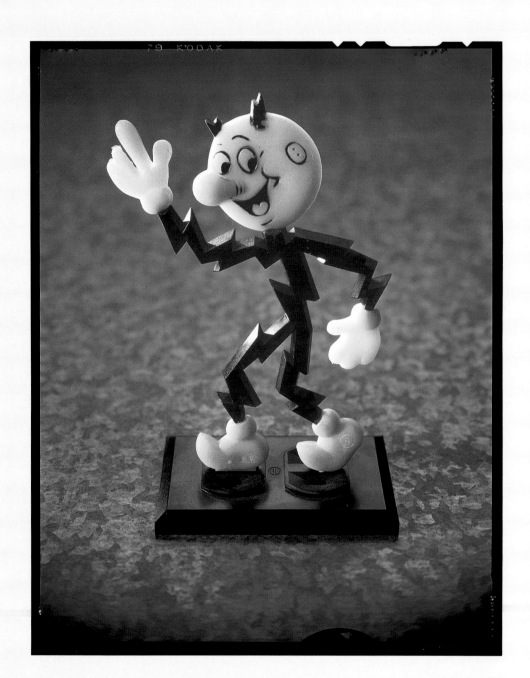

**Reddy
Kilowatt**
*Reddy Kilowatt,
Inc. utility
company
promotions
1961*

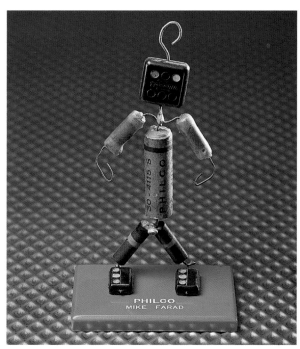

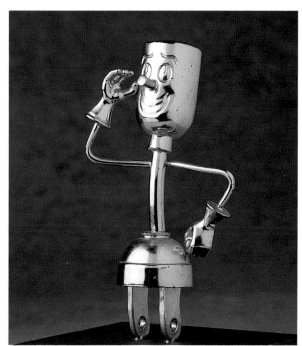

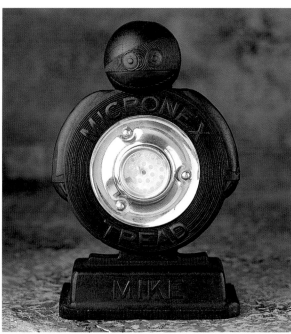

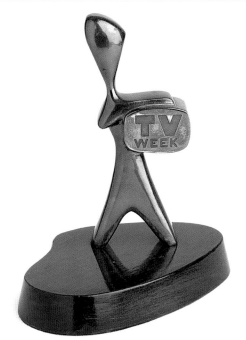

Mike Farad
Philco hi-fidelity products
late 1950s

Willie Wiredhand
Kay Electric Cooperative utility company promotions
1975

Micronex Tread Mike (England)
Micronex tread tires
1930s

Googie Style
TV Week
1971

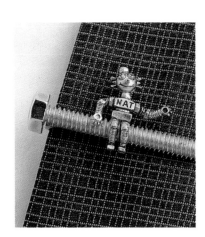

NAT
National Screw &
Mfg. Company
mid-1950s

NAT
National Screw &
Mfg. Company
mid-1950s

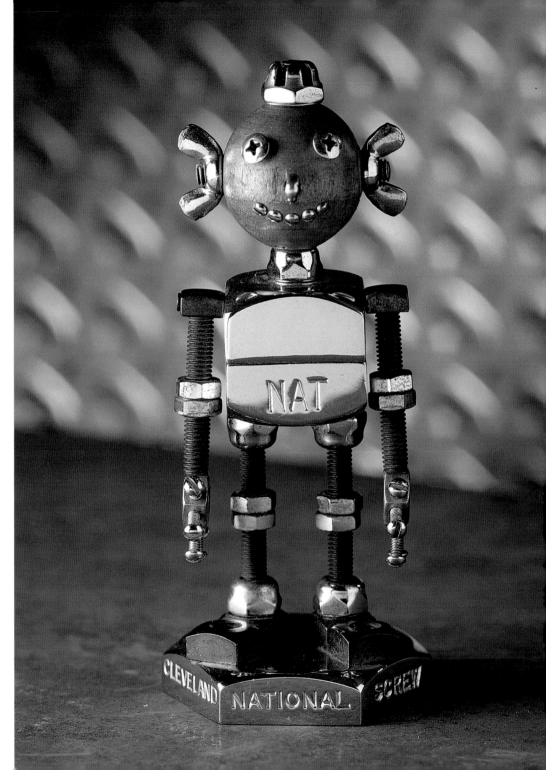

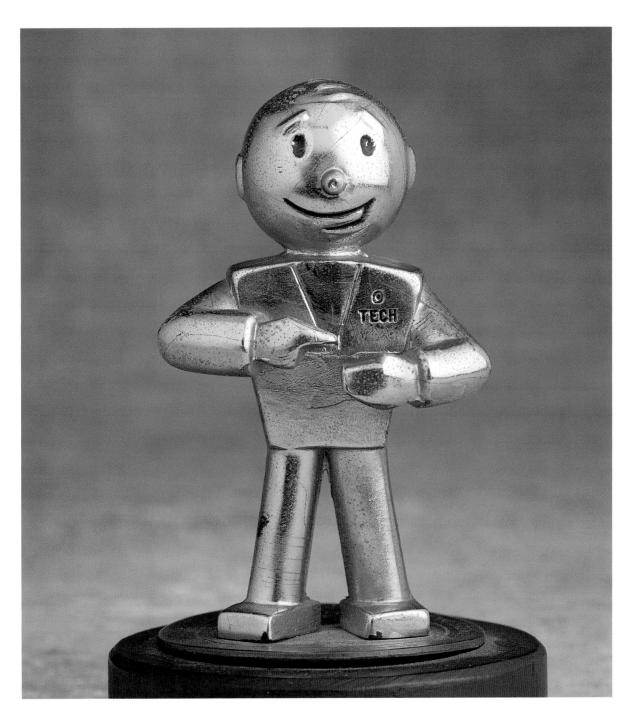

Tech
*Chrysler
Corporation
Master
Technician
service award
1957*

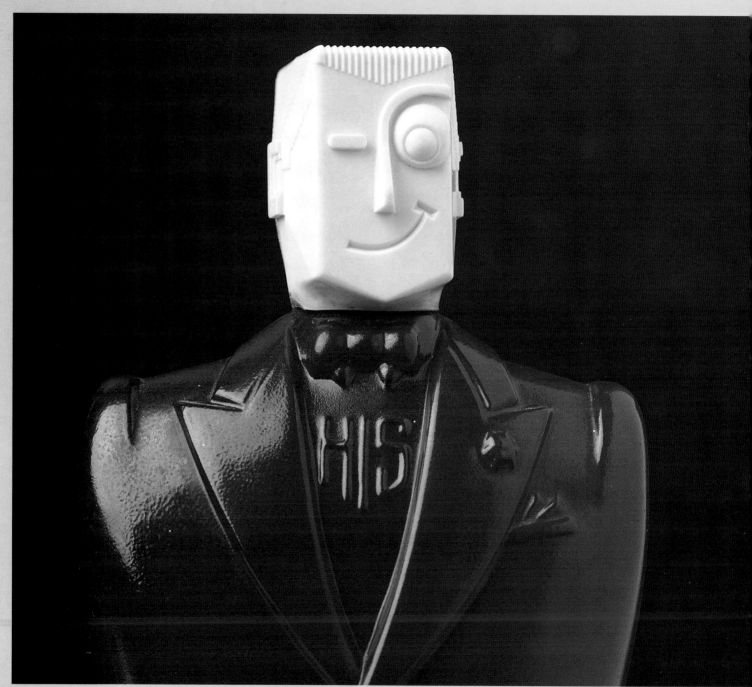

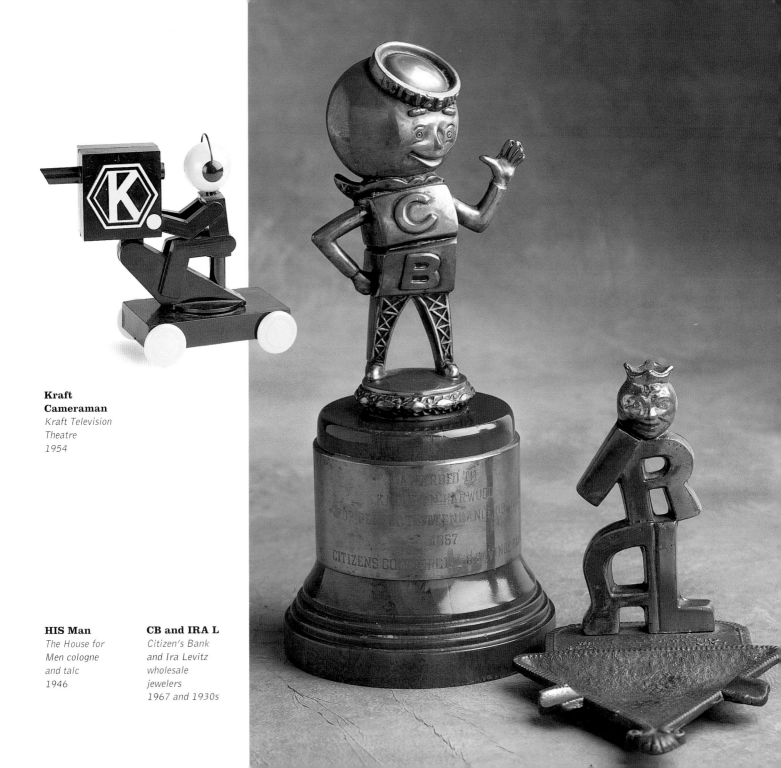

**Kraft
Cameraman**
*Kraft Television
Theatre
1954*

HIS Man
*The House for
Men cologne
and talc
1946*

CB and IRA L
*Citizen's Bank
and Ira Levitz
wholesale
jewelers
1967 and 1930s*

Clanky
*Clanky chocolate-
flavor syrup*
1963

NABISCO
NATIONAL BISCUIT COMPANY

7¼ OZS. NET WT.

"SPOON SIZE"
JUNIORS
100% WHOLE WHEAT CEREAL ®

THE
"SPOONMEN"

NATIONAL BISCUIT COMPANY

KIDS!
Get this 101st
CAVALRY
CANTEEN

CLANKY
CHOCOLATE
FLAVOR SYRUP

The Spoonmen

Nabisco "Spoon Size" Juniors shredded wheat cereal
1958

e (German)

German energy company promotion
1980s

Unifax Astroboy (Korea)

Daewoo fax machines
1993

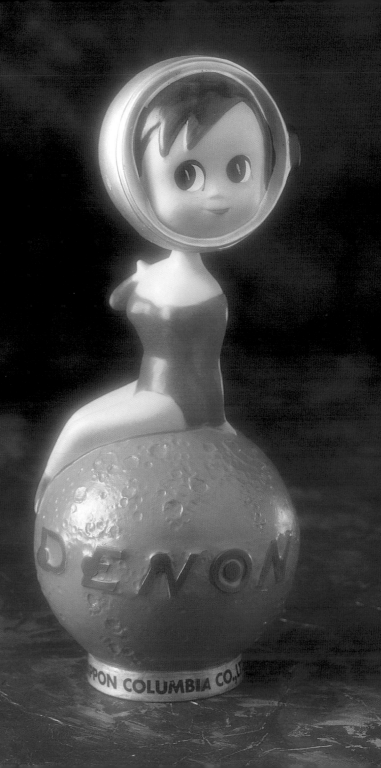

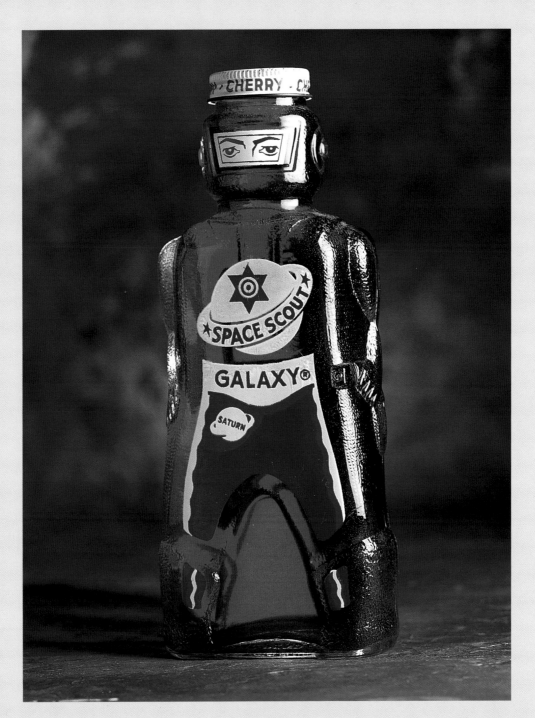

Space Scout
*Galaxy syrup
late 1950s*

**Denon
Astrogirl
(Japan)**
*Denon hi-fidelity
products
1960s*

Cartoons Rule!

At the turn of the century, moviegoers reportedly ran screaming from the cinemas when the locomotive on the screen appeared to be heading straight into the audience. By the 1940s, no one was likely to make such a mistake. People had become familiar enough with the medium to realize that what they saw on the picture screen was not real. This seemingly inconsequential fact demonstrates how drastically a technology (in this case, movies) can change the way we *perceive* things. Movies, photography, and modern art all helped increase the visual sophistication of the average Joe.

Visual sophistication is not simply about being able to recognize that what is on the screen can't hurt you. It also affects the way people interpret symbolic information. Throughout the first half of this century, artists continued to experiment with the visual arts, looking for new vocabularies with which to express their ideas. At the same time, motion picture technology was changing and improving. The net effect was a quantum shift in the way we all look at things.

None of this was lost on the advertisers, who were quick to change with the times. From the turn of the century until the advent of television, advertising

Big Shot
Big Shot chocolate flavored syrup 1963

characters steadily became more stylized and cartoonish or abstract. Compare any ad characters from the turn of the century with those created in the forties and you'll see how much the styles changed. Compare, for instance, the realistic appearance of the Quaker Oats Man with Bill Twell, the little fellow used by the Bilt Well Wood Work Company; or compare the Smith Brothers of cough drop fame with the Pet Milk Company's Big Shot.

Cartoons came into their own during this century, first in the newspapers and periodicals at the turn of the century and later in the animated cartoons of Warner Brothers and Disney. Everybody, it seemed, loved cartoons.

Buster Brown was the first popular cartoon character to become an advertising icon. Created by cartoonist Richard Outcault, the *New York Herald* comic strip featured a prim-looking boy and a talking dog named Tige. Buster was constantly getting into trouble and constantly vowing to change his ways. In 1903 George Brown, owner of the Brown Shoe Company, secured the rights to use Buster Brown as the ad character for his line of children's shoes. As a further gimmick, Brown used dwarves dressed like Buster Brown to travel from town to town, selling his shoes. Ads for the shoe company announced: "I'm Buster Brown, I live in a shoe. That's my dog Tige, he lives there too." Unfortunately for George Brown he did not get the exclusive rights to use Buster Brown. Outcault also sold the character to dozens of other companies selling everything from toys and clothing to cigars and whiskey. Today only the shoes and the clothing lines still exist.

Not all cartoon characters start life in comic strips or in animated shorts. Golly—the little black rag doll used by James Robertson & Sons, a British marmalade and jam company—got its start in America, where women made the dolls for their children to play with. While on vacation in Canada, one of the Robertson sons saw one and decided to use the little toy as the company's advertising character. Golly was the black stereotype reduced to its simplest and (fortunately for the jam company) most innocuous elements. It has charmed generations of children and is also a popular character in a series of children's books. Golly demonstrates succinctly the advantages of using a cartoon for your advertising character. A more human portrayal of Golly would not have lasted through the sixties, but cartoons are harder to nail down.

Cartoon art is the art of abstraction: reducing recognizable objects and people to their simplest elements. At times, cartoon abstraction verges on

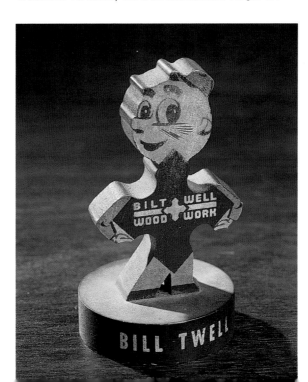

Bill Twell
Bilt Well Wood Work
1950s

**The Pep Boys:
Manny, Moe &
Jack**
*Pep Boys Stores
1939*

fine art.
French designer Adolphe Cassandre's work is a case in point. Cassandre worked in both the fine arts and graphics fields. In 1932, he created an ad campaign for Dubonnet that shows how well cartoons, graphics arts, and advertising can work together. The Dubonnet campaign first materialized as a series of posters on the streets of Paris. The posters featured a man sitting at a cafe table enjoying a glass of Dubonnet. Cassandre's humorous and geometrical ads combine equal parts of futuristic precision and freewheeling, cartoon charm. The campaign became so well known on both sides of the Atlantic that when Schenley

liquor, which distributed Dubonnet in the states, chose to advertise the product, it did so with ads featuring the Dubonnet Man under the headline "That man is here again."

Sometimes cartoons are exaggerations of the normal form. A favorite version of this is the big-headed character, which is a subset unto itself. Take a relatively realistic looking character, such as Benny Mautz, the Mautz Paints Painter, and give it an oversized head and the character moves out of the human category and into the realm of cartoons. Some big-headed characters, such as Lennie Lennox (Lennox Furnace Company) and Freddie Fast (Douglas Oil Company) are cartoonish anyway, even if their heads are correctly proportioned. Others, such as the Pep Boys, are based on real people, but the big-headed rendering in its advertising effectively converts them into icons.

Another variation on the big-headed advertising character is the bobber. Bobbers are those papier-mâché dolls with oversized heads mounted on springs that often show up in car windows. Bobbers are not necessarily used only to advertise big-headed characters. Sometimes real people are converted into big-headed characters for the sake of creating a bobber doll. The Brylcreem Man and his wife and Colonel Sanders got the bobber treatment.

Cartoon styles, like any other art form, change from decade to decade. During the fifties, for example, cartoons became distinctly stylized. The primary force behind this change was a new animation company called United Productions of America. UPA was started by a band of Disney cartoonists who were so fed up with the oppressive working environment at Disney they decided to start their own company. UPA abandoned the

hyperrealistic style used in most cartoons of that period in favor of a looser, more abstract vision. Backgrounds in some UPA cartoons consist of nothing more than a few splashes of color and some squiggly lines. The cartoons were so successful that, in 1950, UPA won an Academy Award for its classic cartoon *Gerald McBoing-Boing.*

UPA took its cue from the popular design styles of the period, and plenty of cartoonists followed suit. It is a style that is now referred to as "Googie." Look in any magazine of the fifties and you'll see dozens of examples of UPA-style cartoons. Advertisers followed suit with characters based upon these styles. Some examples of this are the Suntory whiskey gangster, Drewry's Brewing Company's Big D, and Germany's HB Cigarette Man. The Coronet Waiter is another Googie-style character. Designed by Paul Rand, the Coronet Waiter has a head shaped like a brandy snifter. His features are simple lines and squiggles.

Cartoons work especially well with amorphous or oddly shaped characters. Mr. Wiggle, General Foods' sugar-free gelatin dessert, featured a character of the same name who was little more than a smiling, cross-eyed, bulb-nosed blob in a bow-tie and a skimmer. A similar-looking character is Mr. Bubble, the smiling pink fellow from the children's bubble bath of the same name.

Curiously, some of the most amusing and weird cartoon characters developed for advertising were created for pharmaceutical companies. CIBA/GEIGY Corporation advertised its Actigall gall bladder medicine with a smiling, pea-green gall bladder. Smith Kline & French Laboratories used Tommy Tagamet, a cheerful pink stomach, to sell its ulcer medicine. Pepto-Bismol also used a character, for a time, called the 24 Hour Bug. He is not as cheery as the Actigall gall bladder and Tommy Tagamet; with his pink eyes and evil grin, the 24 Hour Bug looks like he's out to cause some mischief.

The wildest of all the medicine characters was the Ritalin Man, also from CIBA/GEIGY Corporation. Ritalin is an amphetamine used, ironically, to calm hyperactive children. It is also used to relieve depression in adults. The character was a giant brown head with a BIG smile on its face. The CIBA/GEIGY Corporation also created green plastic statuettes of the character showing the before (grumpy) and after (happy) effects of the drug.

If during the fifties cartoons became looser and

Mr. Wiggle
*Jell-O brand gelatin dessert
1966*

more abstract, during the sixties they became downright crude. Some look as if they were scribbled by hyperactive two-year-olds. Nonetheless, these characters succeed where more detailed and geometric figures might fail. These cruder, childlike drawings attract the attention of an audience inured to the more carefully and elaborately illustrated

characters. The best, and easily the most famous, representative of the childlike drawing is Mr. Zip.

By 1963, the U.S. Mail system was drowning under its own mass. Methods of letter dispersal that had worked twenty years earlier were no longer viable. Postmaster General J. Edward Day proposed a new system of postal codes to help process the mail. Initial reactions to the plan were extremely negative. Americans cherished their individuality and viewed postal zoning as an attempt by big government to number and monitor them.

While on an airplane trip, Day was fortunate enough to sit next to AT&T chairman Frederick Kappel. Kappel related the problems that the phone company encountered when it switched to digital dialing and area codes. He warned Day that unless properly handled the American public would reject postal zones. With some help from AT&T, the Post Office created an ad campaign using a character called Mr. P.O. Zone. When the Post Office adopted the name ZIP Code for its system (which stands for Zoning Improvement Plan), the character became Mr. ZIP. Mr. ZIP was a hit and helped ease Americans into the annoying practice of ZIP coding their letters.

The number of cartoon advertising characters increased substantially during the forties, but it was a drop in the bucket compared to what happened in the fifties. Cartoon characters underwent a metamorphosis that would change them—and us—forever. All thanks to a new tool called television.

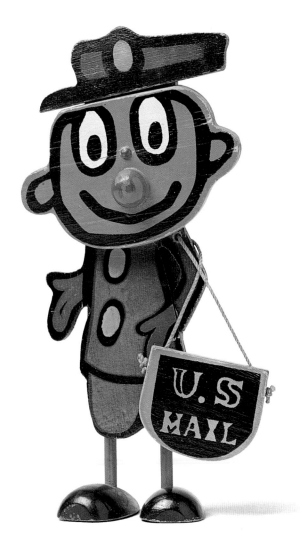

Mr. ZIP
U.S. Postal Service ZIP code promotion mid-1960s

Mr. Bubble
*Mr. Bubble
bubble bath
1970s and 1968*

HB Man
*HB cigarettes
1970s*

**Coronet
Waiter**
*Coronet brandy
1950*

**Suntory
Gangster**
*Suntory whiskey
1970s*

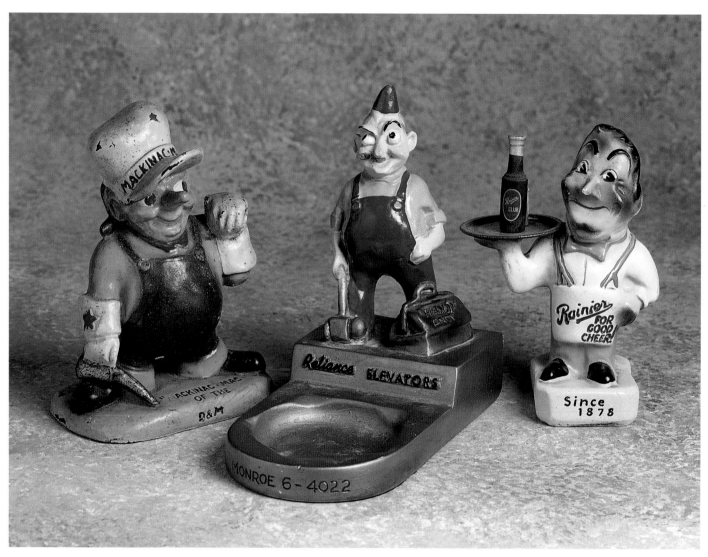

At your service:

Mackinac Mac

Detroit and Mackinac Railroad 1940s

Handy Andy

Reliance Elevators service and repair mid-1950s

Rainier Waiter

Rainier beer 1956

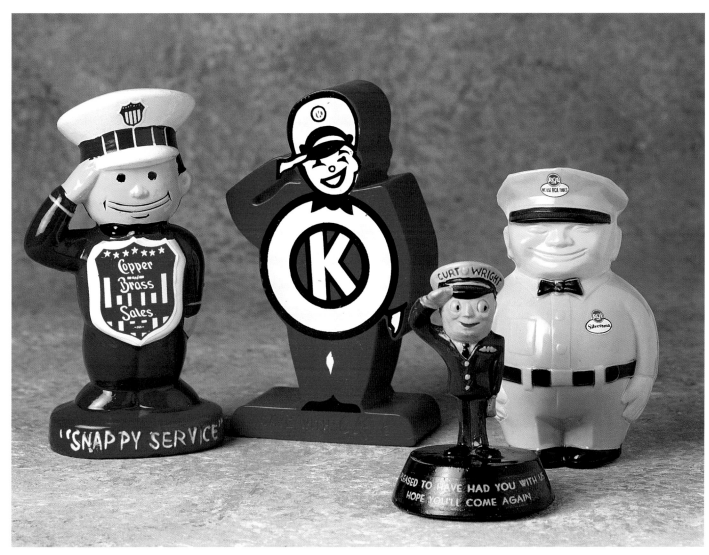

At your service:
Snappy
Copper and Brass Sales, Inc.
1970s

OK
OK Rubber Welders
"Autofloat" tires
1960s

Curt Wright
Curt Wright airlines
late 1950s

TV Joe
RCA Silverama tubes
early 1960s

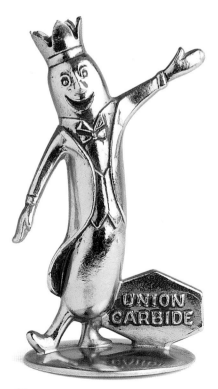

King Carbide
*Union Carbide
industrial gases
unknown*

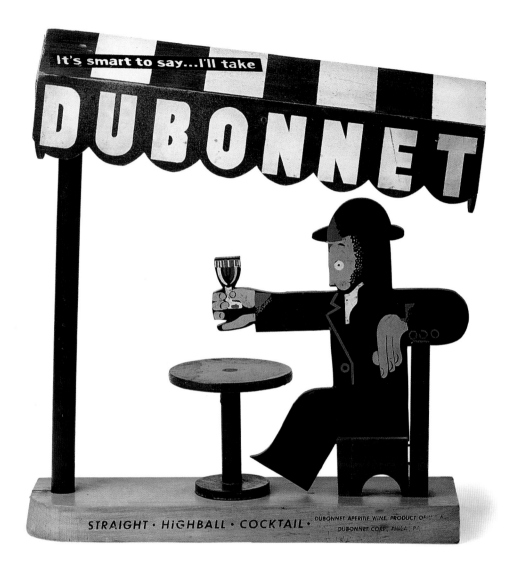

**Dubonnet
Man**
*Dubonnet aperitif
wine
1956*

Big-headed boys: Lennie Lennox
Lennox furnaces and heaters
1949

Freddie Fast
Douglas gasoline service stations
1976

Clark Bar Boy
Clark candy bar
1960s

Perky
*Dr. Pepper per
capita sales
award
late 1950s*

**Buster Brown
and Tige**
*Buster Brown shoes
1960s*

Big Aggie
*WNAX radio
station
mid-1940s*

**Working
women:
Hoover
Housewife**
*novelty bobber
with Hoover
reference
early 1960s*

**Miss
Palmdayl**
*unknown
mid-1940s*

Big Aggie
*WNAX radio
station
mid-1940s*

"Suzy Smart"

"Brother – You're strictly from hoover!!!"

Miss PALMDAYL from California

WHAX

Big Aggie

**Brylcreem
Man and Wife**
*Brylcreem hair
products
early 1960s*

a little dab'll *do Ya!*

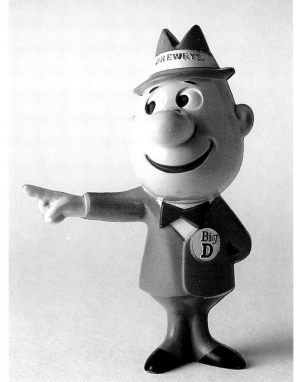

Big D
Drewry's beer
1957

Phil Quota
*Sears Roebuck
and Company
sales quota award
early 1950s*

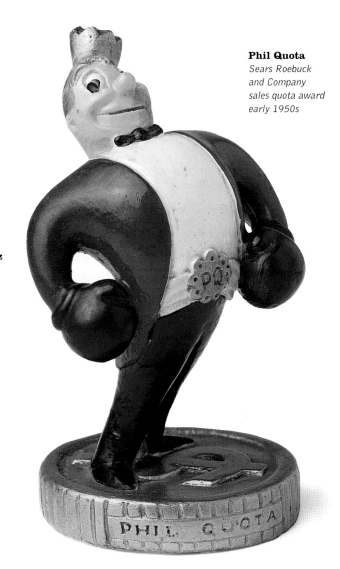

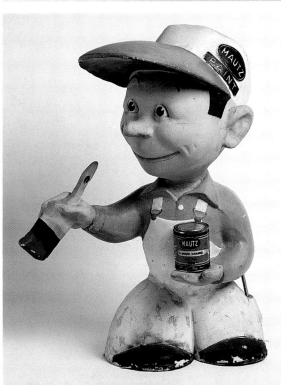

Benny Mautz
Mautz paints
1950s

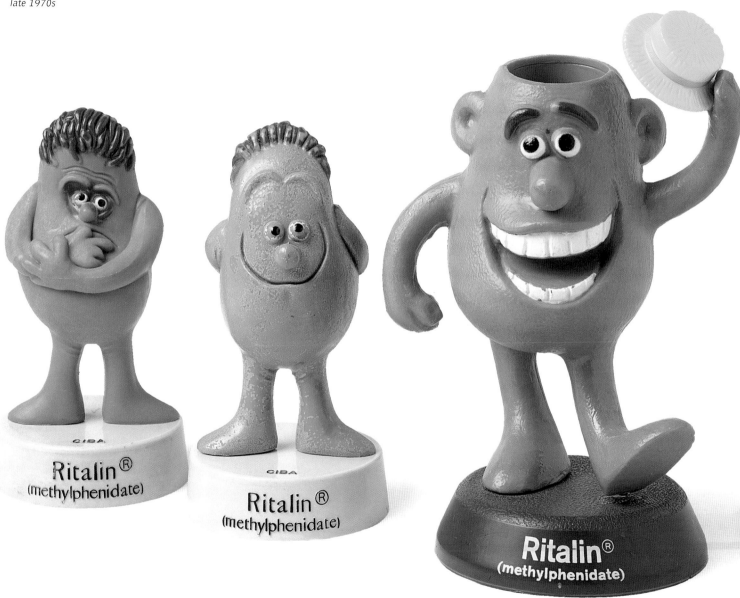

Ritalin Men
*Ritalin
medication for
depression
late 1970s*

**Actigall
Gallbladder**
*Actigall gallstone
medicine*
1989

**Tommy
Tagamet**
*Tagamet ulcer
medication*
1989

24 Hour Bug
Pepto-Bismol
1970s

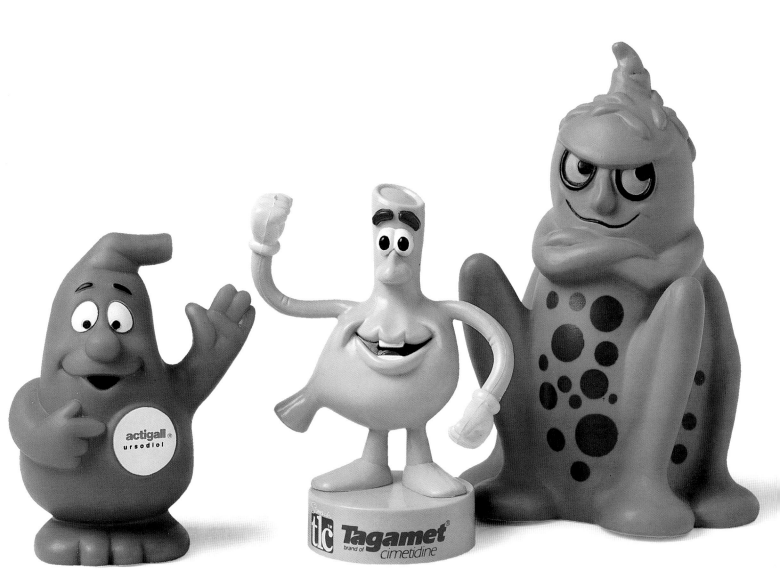

Television and Personalities

Sugar Pops Pete
Kellogg's Sugar Pops 1958

During the early fifties, a revolution swept America as profound in its influence on society as the Industrial Revolution had been a century earlier. This was the Age of Television. At the start of the fifties, only a few homes in the major cities had access to television. By the middle of the decade, nearly half the households in America were wired for it. At first, no one thought much about the potential effects of television on society. The initial perception of the medium was that it was radio with pictures. Early shows amply demonstrate the result of this attitude. Advertisements often featured the program hosts standing and talking endlessly about their sponsor's products. It was boring, but this was at a time when proud television owners were still watching test patterns.

Television made ad characters real. A face on a box was no longer enough. The successful character needed a personality; it had to be somebody. Advertising agencies of America came into their own at this time. It was the era of the gray flannel suit, when Madison Avenue became a household name.

Prior to television, all a character had to do was look good and attract

attention. Television upped the ante; now a character had to be somebody as well. Not all characters were equipped for the change. Snap!, Crackle!, and Pop! and the Campbell Kids were engaging enough to make the leap into animated commercials. The Quaker Oats Man didn't even bother to try. Elsie the Cow appeared in a few animated cartoons, but she is better remembered as an image rather than a personality.

How well the older characters adjusted to the new medium of television depended in part upon the cleverness of the company's advertising agency. Pillsbury's Jolly Green Giant wasn't really television material. After a few failed attempts to give the character personality, the company settled for long shots of the giant standing in a valley, giving his trademarked Santa laugh.

Realizing the limited potential of this approach, Pillsbury asked its ad agency, Leo Burnett, to come up with a new campaign. In 1968, Burnett created Little Green Sprout, the element that had been missing from Pillsbury's commercials all along. Sprout is a variation on the mischievous boy model. He runs around the valley (something the giant cannot do) getting into all sorts of trouble and charming television viewers

in the process. The relationship between the giant and Sprout is never defined. Is he a son, or just a young admirer? We're never sure. It is no surprise that the little fellow was an immediate success.

One of the first of the fully realized TV personalities was Speedy Alka-Seltzer. Speedy was created by Bob Watkins for his friend Chuck Tenant, the two of them army buddies during World War II. After the war, Watkins became a commercial artist; Tenant got a job with Wade Advertising in Chicago and was assigned to handle the Miles Laboratories account. When Miles wanted a new campaign for its Alka-Seltzer Tenant called his old friend, asking for some sketches for a suitable ad character. It took Watkins three hours to come up with Speedy (originally called "Sparky").

Speedy created the paradigm that others would follow throughout the fifties—the ever-cheerful little fellow offering a solution to your problems, especially if your problems included indigestion or a hangover. Speedy was so ingratiating that only a Grinch could object to the lad. Speedy appeared until the mid-seventies, when he was replaced by a series of award-winning ads including "Man vs. Stomach" (an animated commercial featuring a man arguing with his stomach), the

Little Green Sprout
Green Giant products
1975

"I can't believe I ate the whole thing" ad, and the "Mamma-mia that's a spicy meat-a ball" ad. In 1980, during the Winter Olympics, Speedy resurfaced in an ad that featured him skiing down the slopes with Sammy Davis, Jr. More recently, Speedy appeared in print ads sporting sunglasses and a Hawaiian shirt.

Some ad campaigns worked equally well on the radio and on television. The Piel's beer ads featured Bert and Harry Piel, two cartoon characters who supposedly owned the Piel Brothers Brewing Company. Bert was a short windbag, full of goofy schemes to help sell Piel's beer. Harry was a tall, quiet fellow who approached Bert's schemes with apprehension. The voices for the characters were provided by the comedy team of Bob and Ray, which accounts for the ads' success on radio as well as television. The characters were initially retired in 1960, but the public demand for them proved so great that they were brought back for several more years.

Sugar Bear
Post Sugar Crisp
1958

Tony the Tiger
Kellogg's Frosted Flakes
1957

Cowboy shows were a popular staple of television in the fifties. Advertisers followed, with characters based on western archetypes. To advertise Sugar Pops, the Kellogg Company created a character called Sugar Pops Pete. Pete spoke with a whistle and used his pistols to impregnate the puffed corn cereal with sugar, while singing: "Oh, the pops are sweeter and the taste is new. They're shot with sugar, through and through." Pete was ostensibly a ground squirrel, but the artist who drew him didn't have a picture of a ground squirrel to use as a reference, so Pete wound up looking as much like a teddy bear as a squirrel. The Continental Baking Company jumped on the cowboy bandwagon with Twinkie the Kid, who advertised its Hostess Twinkies on the Howdy Doody show. Twinkie the Kid wore a red bandana with blue spots and black boots with yellow stars on them.

Another, even more popular character of the fifties was Nabisco's Buffalo Bee. The Bee wore a striped shirt, a cowboy hat, two six-shooters and a red bandana. His voice was provided by Mae Questal, who also did voices for Olive Oyl and Betty Boop. Buffalo Bee was a big hit with kids and even appeared in his own comic books.

When the public began to lose interest in westerns in the mid-sixties, the cowboy advertising

characters were the first casualties. Buffalo Bee was replaced with Buddy Bee, who resembled Buffalo Bee but lacked the former character's wardrobe and charisma. Sugar Pops Pete was replaced by various characters, the last of which was Poppy, a lovable little porcupine, who although charming didn't measure up, and eventually disappeared. Today, Sugar Pops (now called Corn Pops, naturally) are advertised with live-action commercials.

In the pantheon of cereal characters, the top dog is a cat named Tony. Tony the Tiger started life in 1952, when he shared packages of Sugar Frosted Flakes with Katy the Kangaroo. (As with other cereals, the word "Sugar" was dropped from the title during the health-conscious seventies.) Kellogg had planned to use a different character for every letter of the alphabet, but Tony's success preempted that plan. In his earliest incarnation, Tony stood on all fours.

Tony, Jr., appeared on Sugar Frosted Flakes packages as early as 1953, and later in a series of commercials that featured Tony trying to teach his son the value of Frosted Flakes for breakfast. Eventually Tony, Jr., was enlisted to sell Kellogg's Frosted Rice cereal. Later on Tony's wife and daughter were added to the commercials. In recent commercials Tony has appeared alone. His family seems to have disappeared. Tony, Jr., has been replaced by real children in a remarkable series of commercials using animation and live action together. Tony is shown coaching live children on how to win with the help of a good breakfast, which in Tony's terms means eating Frosted Flakes.

Some advertisers realized that if they wanted to create memorable, animated advertising characters, it wouldn't hurt to seek the assistance of people who had some experience at making animated cartoons. When the Seven-Up Company asked the Leo Burnett Agency to create a new ad campaign, Burnett turned to Disney. (Seven-Up was a sponsor for Disney's television shows, so it was also agreed that the new ad campaign would first appear during one of them, the Zorro series.) The character Disney came up with was Fresh-Up Freddie, a cheerful and manic rooster who got into all sorts of predicaments and ran around singing, "Nothing does it like Seven-Up, Seven-Up! Ooo-oo! Ooo-oo! Nothing does it like Seven-Up!"

The Fresh-Up Freddie ads were a big hit at the time, but they are virtually forgotten today by everyone except advertising collectors and historians. They are unquestionably well done, and they helped boost the sales of Seven-Up at the time, but Fresh-Up

Bert and Harry Piel
Piel's beer
1956

Freddie does not linger in our memories because we never found out what the little rooster was really like. In nearly every commercial he dons a different hat and a different personality. The only constant is his manic enthusiasm and love of Seven-Up.

UPA Studios was hired to create animated ads for Quaker City Chocolate and Confectionary's Good and Plenty candies. It was in these commercials that we were first introduced to Choo-Choo Charlie. Charlie was a little kid who dreamed of becoming a railroad engineer. Using his box of Good and Plenty candies as a prop, Charlie created an imaginary world in which he was an engineer. He shook the box to create the sound of a train chugging along, and he blew into the box to produce the train whistle. When his friend eats one of the candies, Charlie complains, "Aww, you're eating my engine."

Although all of the major animation studios have created advertisements, Jay Ward did it best. At that time, Jay Ward's animation studio was riding high with the success of its popular cartoon show *Rocky and His Friends*. The show starred a flying squirrel named Rocky, a Moose named Bullwinkle, and two lovable villains named Boris Badenov and Natasha Fatale. In 1963, The Quaker Oats Company hired Jay Ward to advertise its new cereal, a sugary, extruded snacklike cereal called Cap'n Crunch. Ward's character of the same name was a lovable if slightly discombobulated old sea captain who, along with his first mate Seadog (who was, in fact, a sea dog) and a crew of children, spent most of his time thwarting the evil pirate Jean LaFoote's attempts to steal their cereal.

Cap'n Crunch proved so popular that Quaker Oats hired Jay Ward again to advertise two more new cereals. The cereals were called Quisp and Quake. For these, Jay Ward created two characters as different as they could be. Quisp was a spaceman based on the Moonman from the Rocky and Bullwinkle cartoons. Quake was a gigantic lumberjack who bore a strong resemblance to Dudley Do-Right. The two characters were constantly fighting over which cereal was better. Most people liked Quisp's character better, and the results showed in the supermarket. Quisp outlasted Quake by several years. In 1985, Quisp also bit the dust, and only Cap'n Crunch survives of Jay Ward's original creations.

The dueling cereals theme was picked up by

Poppin' Fresh
Pillsbury ready-to-bake products 1970s

General Mills with the introduction of Franken Berry, Count Chocula, and Boo Berry.

Of all the television age ad characters, there is none more perfect in design and execution than Poppin' Fresh, the Pillsbury Doughboy. He has been going strong for over thirty years and shows no signs of slowing down. Among collectors he is a gold mine—telephones, cookie jars, salt and pepper shakers, and ceramic banks have been made in his image. During the seventies, vinyl figurines of him and his entire family were sold at Sears, including his Uncle Rollie, his children Popper and Bun Bun, and his cat and dog!

Poppin' Fresh was created by Rudi Perz, who worked for the Leo Burnett ad agency. Perz was enlisted to help create an ad campaign for Pillsbury's line of refrigerated doughs. In those days, Pillsbury's dough products were designed to pop open dramatically after a sharp rap on the side. Perz imagined a little creature made of dough popping out of the newly opened container.

For the voice of Poppin' Fresh, vocal impressionist Paul Frees was hired. Like Mel Blanc, Frees was a wizard at creating startlingly different voices. It was he who did the voice for Boris Badenov, as well as the narration in the Rocky and Bullwinkle cartoons. He also is the man who recited the classic "People of the Planet Earth" speech in the fifties sci-fi film *Earth versus the Flying Saucers*.

In the early commercials, Poppin' Fresh was extremely bashful, always blushing after compliments and pokes to his stomach. Today's Poppin' Fresh is less shy. In recent commercials he is shown playing the harmonica, singing the blues, rapping, and playing guitar.

Advertising personalities aren't always cartoons. In 1963, McDonald's introduced a red-headed clown named Ronald McDonald to help sell its burgers. In the earliest commercials, Ronald said nothing—mostly because the man playing him spoke with a Russian accent. Eventually he was replaced by the *Today Show*'s meteorologist, Willard Scott, who was working as a Washington, D.C., weatherman at the time. Over the years, with several people portraying Ronald McDonald, he has been joined by other creatures in his fantasy world, including Big Mac (a policeman), the Hamburglar, and Mayor McCheese.

Burger King felt the effects of the Ronald McDonald campaign and came up with its own character—a king named Burger King. The character was popular, but he was a little too much like Ronald for his own good. Nonetheless, Burger King scored points with younger viewers and appeared in television commercials throughout the seventies.

Toucan Sam
Kellogg's Froot Loops cereal
1965

Cap'n Crunch
Quaker Cap'n Crunch cereal
1963

Quisp
Quisp cereal
1974

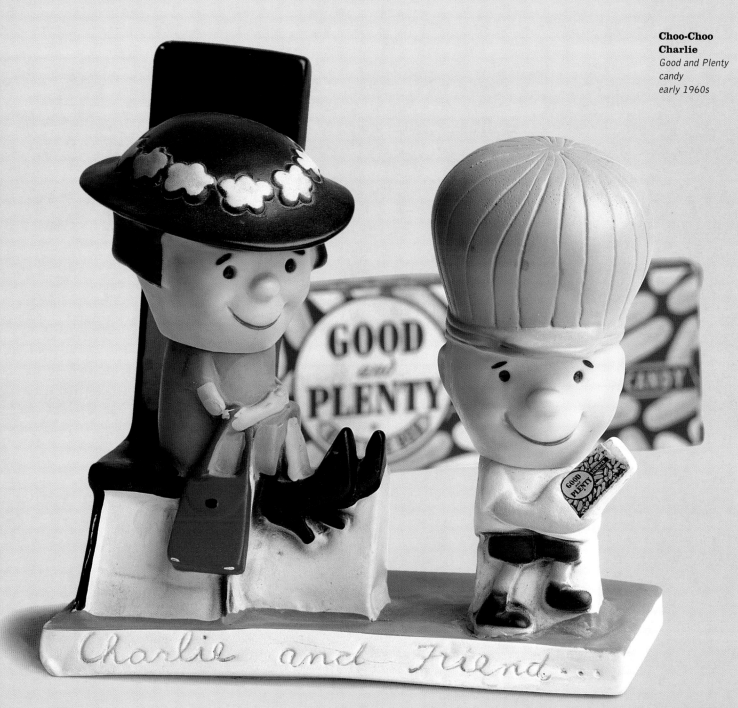

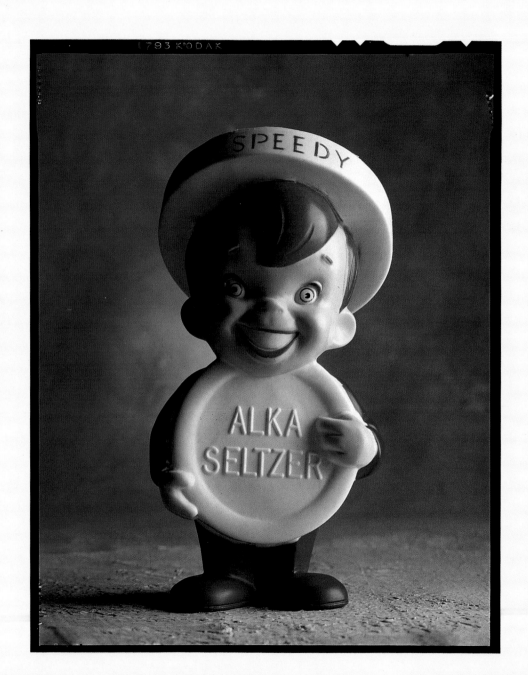

Speedy Alka-Seltzer
Alka-Seltzer
late 1950s

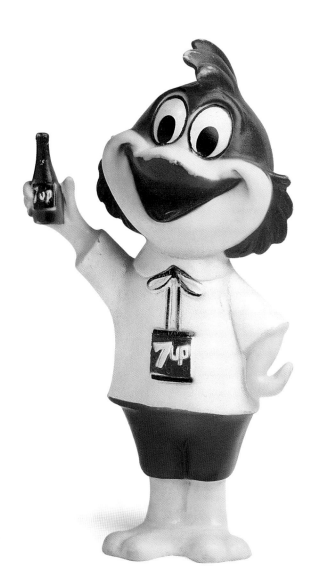

**Fresh-Up
Freddie**
7-Up
1959

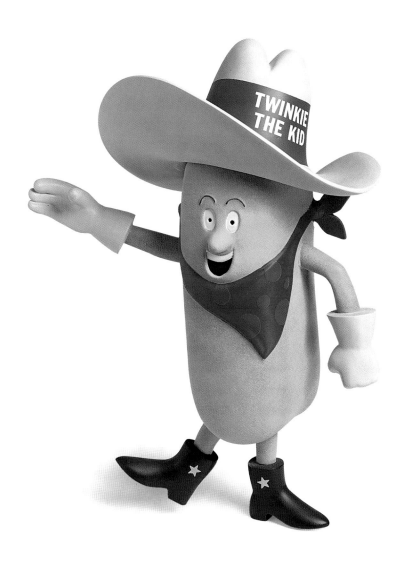

**Twinkie the
Kid**
Hostess Twinkies
1990

**Cereal
Characters:
Trix Rabbit**
*General Mills
Trix cereal
1977*

Twinkles
*General Mills
Twinkles cereal
early 1960s*

Toucan Sam
*Kellogg's Froot
Loops cereal
1984*

**Tony the
Tiger**
*Kellogg's Frosted
Flakes cereal
1974*

**Jean LaFoote
and Cap'n
Crunch**
*Quaker Cap'n
Crunch cereal
1974*

Losers, Nasties,
and Cool Cats

After the development of personality-based characters, advertising agencies started to experiment with personality types in much the same way as they had experimented with character form during the thirties and forties. Corporations usually liked their characters to reflect strength, heroism, and honesty. Advertising agencies complied but recognized that these attributes, while noble, were boring to television viewers. Advertisers started experimenting with ignoble characters and found that people liked them better and—more importantly—remembered them longer.

Unlike such characters as Tony the Tiger and the Hamm's bear, who have often found themselves at the short end of the stick but occasionally came out ahead as well, loser characters never come out ahead. The true loser is always at odds with the universe; unlike cheerful or heroic characters, lovable losers are often the butts of the jokes. Some are victims of circumstance, while others deserve everything they get. One of the first and still one of the best of these characters was the Burgie Man, who originally appeared in television commercials during the fifties. This sad little fellow

Burgie
*Burgermeister
beer
late 1960s*

appeared in a series of classic commercials during the fifties and sixties. Things never quite worked out right for Burgie. In one commercial, for instance, Burgie appeared on the screen with a pussycat in tow, instructing us that we should buy Burgermeister beer because it was the cat's . . . "Meow," cried the cat. Burgie looked perplexed. "He was supposed to say 'pajamas,'" he informed us.

This cockeyed humor kept Americans laughing. Clearly Burgie was based on the cartoon style developed by the United Productions of America animation studio. Burgie is a representative of the "nebbish": a sad-faced character for whom things never quite go right.

One of the greatest losers of all time first showed up in 1959. He is the Trix Rabbit. Created by Stanley Baum at the DFS advertising agency, the Trix Rabbit is the first in a long line of true losers. While Burgie seemed like a true loser, we knew that his problems were more a matter of self-confidence than of fate. The Trix Rabbit, on the other hand, knows what he wants. He does not lack self-confidence, yet he still cannot win. His inability to get what he wants is dictated by the decisions of others. There is nothing in the world that the Trix Rabbit wants more than a bowl of Trix cereal, yet he is denied this by children who scold him with the now famous line, "Silly rabbit, Trix are for kids."

The Trix Rabbit strikes a chord with children and adults alike. Children laugh at the cartoons because of the role reversals; usually it is the children who are kept from doing what they want. Adults laugh at the cartoons because they know exactly how the rabbit feels. Many

other successful advertising characters that followed owe thanks to the Trix Rabbit, including the Lucky Charms Leprechaun (who is often thwarted by children) and Sonny the Cocoa-Puffs Bird (whose love for Cocoa-Puffs usually prevents him from accomplishing things).

At first glance, Charlie the Tuna seems to be a variation on the Trix Rabbit theme. For reasons unknown, Charlie wants the StarKist Tuna Company to accept him as a worthy candidate for gutting, chopping, cooking, and canning. Charlie (whose voice was originally provided by Herschel Bernardi) tries to impress StarKist with his taste by reading

Trix Rabbit and Sonny the Cuckoo Bird
General Mills Trix and Cocoa Puffs cereals early 1960s mid-1960s

poetry and listening to classical music, but the answer is always the same: "Sorry Charlie, StarKist doesn't want tuna with good taste, StarKist wants tuna that tastes good." Both the Trix Rabbit and Charlie the Tuna are denied what they want by others, but in Charlie's case the problem is partly his own fault. He just doesn't get it.

In a similar vein are the nasties. These are the characters that are not just losers, they are evil. Nasties first appeared in television advertising during the fifties. In the Ipana toothpaste commercials, Bucky Beaver was pitted against the evil D. K. Germ, a gray blob of a character who was always trying to ruin Bucky's day. When threatened, Bucky pulled out his tube of Ipana toothpaste and knocked the villain down. The Bucky Beaver commercials were some of the best known commercials of the fifties, but that did not stop Ipana toothpaste from fading into obscurity.

Around the same time, a whole gang of nasties appeared in the Bardahl commercials. These cartoon

Raid Bug
Raid insecticide
1980s

commercials were takeoffs on Chester Gould's Dick Tracy comic strip. Like Dick Tracy, Bardahl was a trenchcoat-wearing police detective who faced a host of improbable bad guys. Evil characters such as "Sticky Valves" and "Gummy Rings" threaten to destroy car engines until Bardahl shows up to save the day.

Bugs are natural candidates for nasties. In the fifties, when the U.S. government launched its antilitter campaign, the character it used to promote the effort was (what else?) the litterbug—a gnarly-looking creature with a cigarette hanging out of the corner of its mouth and an eye patch over one eye.

Another batch of bugs that got their start in the fifties, and are still going strong, are the Raid Bugs. The Raid insecticide commercials follow a style similar to the Bardahl ads. In the early Raid commercials, the bugs—like the Bardahl bad guys—are short on character; they are simply menacing things for Raid to combat. This all changed when a cartoonist named Don Pegler joined the team at Foote, Cone and Belding. Pegler's bugs are almost lovable. These grungy little freeloaders are only interested in a free meal. They sit and daydream about how cushy things are going to be for them in their new digs, until the giant Raid aerosol shows up and puts an end to their speculations and their lives.

The Bardahl ads were popular, but the folks at Bardahl never tried to market its characters as advertising premiums. Not so with Raid. The Raid Bugs are some of the most popular advertising premiums available among collectors. Don Pegler's bugs have personality.

The nasties in the Raid and Bardahl commercials are held in check by the good guys. In the case of the Noid, the only thing that stops this ornery fellow

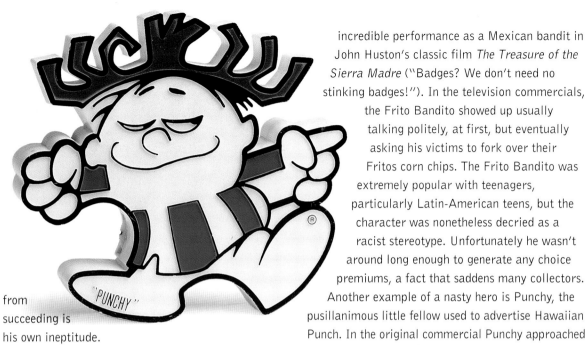

from succeeding is his own ineptitude.

When Domino's Pizza executives were first approached with the idea for the Noid commercials, they hated it. The concept of using a bad guy as its advertising icon initially horrified the conservative company.

In spite of the Noid's popularity, and the increased sales due to additional advertising marketing, the character was quietly phased out in the early nineties. The folks at Domino's never liked the Noid and wanted a safer, less provocative campaign. The decision was a mistake and everyone except at Domino's knew it, but they, after all, were the only ones who needed to be sold on the Noid, and they were the only ones who weren't.

Nasties are nearly always the brunt of the joke in commercials. We laugh at the Noid and the Raid Bugs for their failures. Not so with the Frito Bandito. He is the rare nasty who also seems heroic. The Frito Bandito is based largely on Alfonso Bedoya's incredible performance as a Mexican bandit in John Huston's classic film *The Treasure of the Sierra Madre* ("Badges? We don't need no stinking badges!"). In the television commercials, the Frito Bandito showed up usually talking politely, at first, but eventually asking his victims to fork over their Fritos corn chips. The Frito Bandito was extremely popular with teenagers, particularly Latin-American teens, but the character was nonetheless decried as a racist stereotype. Unfortunately he wasn't around long enough to generate any choice premiums, a fact that saddens many collectors.

Another example of a nasty hero is Punchy, the pusillanimous little fellow used to advertise Hawaiian Punch. In the original commercial Punchy approached a big, goofy-looking fellow in a Hawaiian shirt and asked: "Would like a Hawaiian Punch?" The big guy (who is known as Oaf) replied "sure," and Punchy promptly decked him.

The Hawaiian Punch commercials first aired on the *Tonight Show* in 1963. At that time the show was hosted by Jack Paar. Paar was so taken aback by the commercial when it first ran that he asked the control room to run it again. Punchy was an immediate hit with everyone (no pun intended) and is still popular.

In a way, Punchy was the first of a new kind of character, called the "cool cat." Cool cats might be slightly amoral but are never downright bad. The cool cat image got its start in the fifties with the beatniks.

One of the first cool cats was Sugar Bear, who advertised Post's Super Golden Crisp. In the sixties Sugar Bear became cool. He bopped through life

using his cereal to help him out of scrapes, while singing: "Can't get enough Super Golden Crisp." The character got his name and his start back when the cereal was still called Sugar Crisp. In his earliest incarnation Sugar Bear was not that hip. He looked liked any other teddy bear on the block. The lyrics to his little song were different then, but the tune remained the same even after the mid-seventies health pogrom removed "sugar" from the title of every cereal.

An even more musical bunch of cool cats are the California Raisins, who strutted their way into American culture in 1986. In the original commercial the raisins danced out of their box singing Marvin Gaye's "I Heard It Through the Grapevine." The commercial was created by claymation master Will Vinton.

The easiest way to spot a cool cat is by the shades. Most cool cats wear sunglasses. The Seven-Up Spots are little more than sunglasses and sneakers. These mischievous little characters pop off of Seven-Up cans and bottles when no one is looking, occasionally disrupting things but never getting caught.

Occasionally a character is a cool cat and a loser at the same time. Chester the Cheetah, who is used to advertise Cheetos cheese puffs, is as cool as they come but often ends up as the butt of the joke.

In 1986, McDonald's joined the cool-cat market with Mac Tonight, an ultracool character with a face shaped like a crescent moon. Mac Tonight sat at a piano, singing the joys of eating at McDonald's to the tune of Mack the Knife, Kurt Weill's lighthearted song about a ruthless German criminal.

Is there any cool cat cooler than the Energizer Bunny? The Energizer Bunny got his start in a series of award-winning commercials. The first commercial showed the bunny outlasting another toy with an inferior battery. At the end of the commercial we saw the bunny marching out of the sound stage while a voice from off-screen said: "Will somebody get the bunny." The commercial was immediately followed by a fake commercial for a nonexistent product. Halfway through the commercial, the bunny came marching along, pounding his drum and disrupting the action on the screen. "It keeps going and going and going," a narrator interjected. The commercial became so well known that soon people did not need to see the setup; they knew the gag. Over the next few months the Energizer Bunny marched through a long series of amusing phony commercials. He became a superstar in his own right and appeared in a new series in which he was attacked by various famous bad guys, including King Kong, Dracula, Darth Vader, and Wile E. Coyote, all of whom failed miserably in their attempts to thwart the rhythmic rabbit.

Cool cats appeal strongly to teenage boys. So when a company creates a cool cat to advertise a product that is not intended for youngsters, some fur is bound to fly. The two most notorious examples of this are Spuds MacKenzie and Joe Camel. Parent-teacher organizations, educational groups, and others have rallied against these two.

Spuds MacKenzie first appeared in 1983. Spuds was usually shown partying at a poolside, surrounded by beautiful women (called the "Spudettes"). The secret of Spuds's *joie de vivre* had something to do with the fact that the dog preferred to drink Bud Light. With the appearance of Spuds MacKenzie, sales of Bud Light soared. Spuds became so popular with teenagers that he was eventually drafted to caution people about the dangers of drinking and

driving. There was a miniscandal when people found out that the dog who played Spuds MacKenzie was, in fact, a female.

Joe Camel first showed up in this country in 1988, but he wasn't new. The camel had been in use in France since 1974 (where they smoke a lot of Camels—where they smoke a lot of everything!). The reaction to Joe Camel was immediate. The American Cancer Society asked the Federal Trade Commission to banish him from advertising. Many people thought the character's face intentionally resembled a penis. Neither the Mezzina-Brown advertising agency nor Nicholas Price, the illustrator, admits to it, saying that this perspective is purely in the eye of the beholder.

Joe Camel took his inspiration, naturally, from "Old Joe," the dromedary who has appeared on Camel cigarette packs since 1913. The original animal was part of the Barnum & Bailey circus. When the circus came to the Winston-Salem area, the people at R. J. Reynolds asked if they could take pictures of some of the circus animals to use on the company's packaging. At first the circus refused, but when the tobacco company suggested that perhaps there would be no one attending the circus because the cigarette plant would stay open those nights, the circus reconsidered.

The tobacco company chose two animals to photograph. One of them was a surly creature by the name of Old Joe. When the camel wouldn't stand still for the picture shoot, the handler slapped it across its face. The animal raised its tail and put its ears back, which is how dromedaries display anger. The photographer took the picture, and this is the image that ended up on the Camel cigarette package.

As long as television continues its reign as our major source of entertainment, we're bound to see more of the personality-based ad characters. As the public grows more sophisticated, advertising companies must think of new ways to capture our attention without appearing trite or obvious. The lines between commercials and entertainment have become nonexistent. This is especially true in children's television, where product marketing sometimes comes before story development. One thing is certain: we haven't seen the last of commercials. They will keep mutating and adapting, always piquing our interest, fascinating and irritating us at the same time. Like the Energizer Bunny, they keep going and going and going

Energizer Bunny
Energizer batteries 1991

Wig-L-Bug
Crescent
Company
1950s

Litterbug
Cecil Dooley
Termite Control
1970s

**California
Raisins**
*California Raisin
Advisory Board*
1987

Hamm's Bear
Hamm's beer
1968

Spuds MacKenzie
Bud Light beer
1989

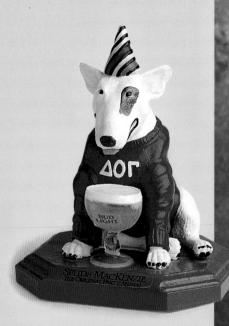

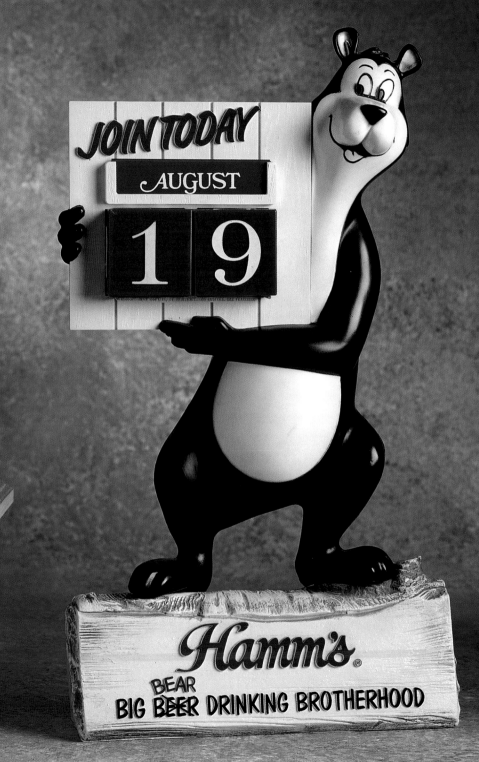

JOIN TODAY

AUGUST

19

Hamm's®
BEAR
BIG BEER DRINKING BROTHERHOOD

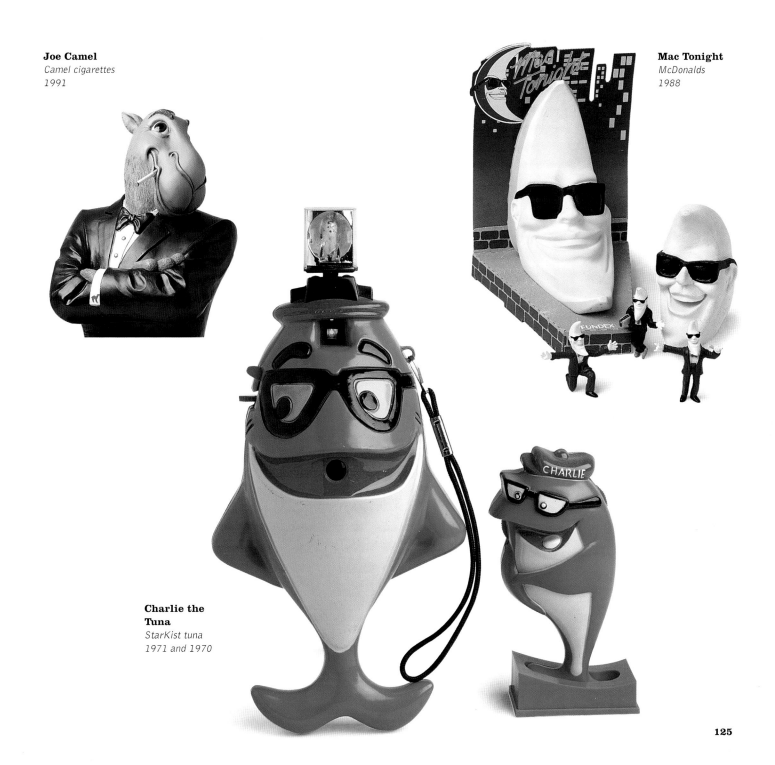

Joe Camel
Camel cigarettes
1991

Mac Tonight
McDonalds
1988

Charlie the Tuna
StarKist tuna
1971 and 1970

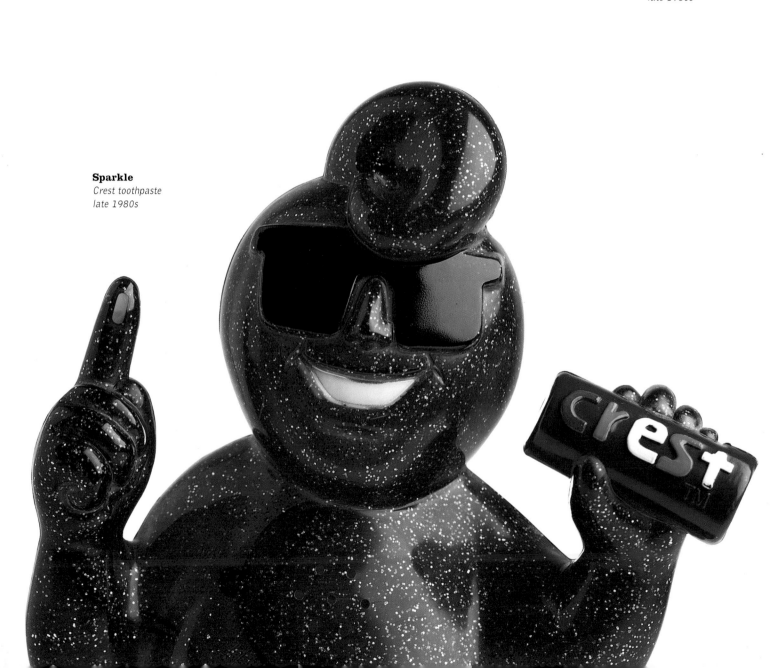

Sparkle
Crest toothpaste
late 1980s

Burgie
Burgermeister
beer
late 1960s

Rarity Guide

Key: **1**=Very Common, **2**=Common,
3=Uncommon, **4**=Rare, **5**=Very Rare

Johnny
Philip Morris cigarettes 1950s

Sun Drop Kid
Sun Drop liqueur unknown

Belt Man
*Royal London
belts
1940s*

Hastings Man
*Casite Motor
Honey
1950s*

Fred Fossil
Fossil Watches
1994